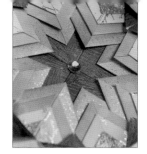

Iris Folding

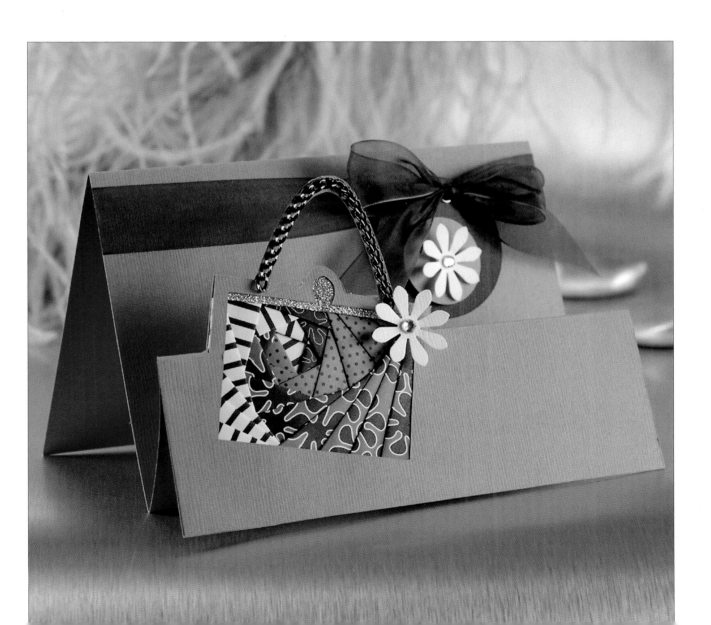

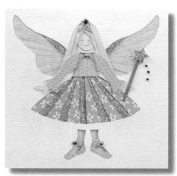

*This book is dedicated with
much love and kisses to
Christian Goodfield.*

Iris Folding

Michelle Powell

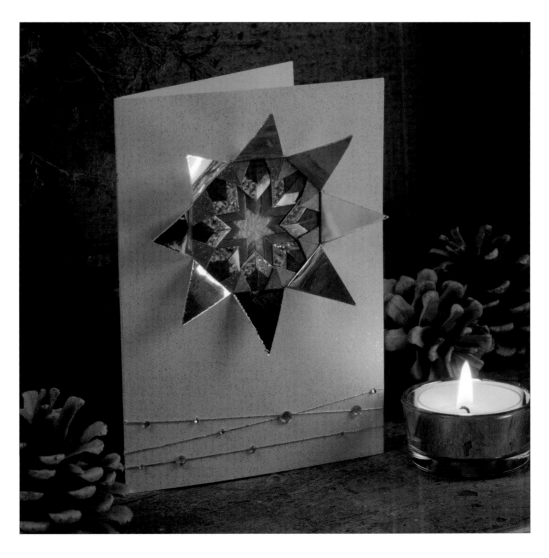

SEARCH PRESS

First published in Great Britain 2008

Search Press Limited
Wellwood, North Farm Road,
Tunbridge Wells, Kent TN2 3DR

Reprinted 2009 (twice), 2010

Text copyright © Michelle Powell 2008

Photographs by Debbie Patterson at Search Press Studios

Photographs and design copyright ©
Search Press Ltd 2008

ISBN: 978 1 84448 316 7

Suppliers

If you have difficulty in obtaining any of the materials and
equipment mentioned in this book, then please visit the
Search Press website for details of suppliers:
www.searchpress.com

Iris folding papers

All of the iris folding papers supplied at the back of
this book, together with sixteen additional designs, are
available in *Michelle Powell's Iris Folding Papers*, ISBN 978
1 84448 402 7, published by Search Press.

Publisher's note

All the step-by-step photographs in this book feature
the author, Michelle Powell, demonstrating the craft of
iris folding. No models have been used.

Printed in China

Acknowledgements

As always I'd like to thank the team at Search Press
for their hard work in producing this book. Thanks in
particular to Roz Dace for continuing to allow me to do
what I love: that is, spend my days covered in glitter and
glue. To Katie Sparkes for her enthusiasm and excellent
editing, Debbie Patterson for her stunning photography
and styling and Juan for his graphic design skills.

Thanks also go to my family: Mum, Dad and Christian,
who come to my rescue with meals, house cleaning and
laundry, not to mention the odd bit of sticking and cutting,
every time I realise that another deadline is approaching
too quickly.

Front cover: Art Nouveau
These graphic rose images are ideal for iris folding.

Page 1: Little Black Bag
*Use striking black and white papers for this chic, feminine
greetings card.*

Page 2: Sparkly Fairy
*Precise placement of your paper strips creates the details
on this pretty fairy.*

Page 3: Christmas Star
*Alter your folding technique to create a star-effect
greetings card.*

Opposite: Tropical Cruise
*Use layers of folded paper strips
to create a sunset at sea.*

Contents

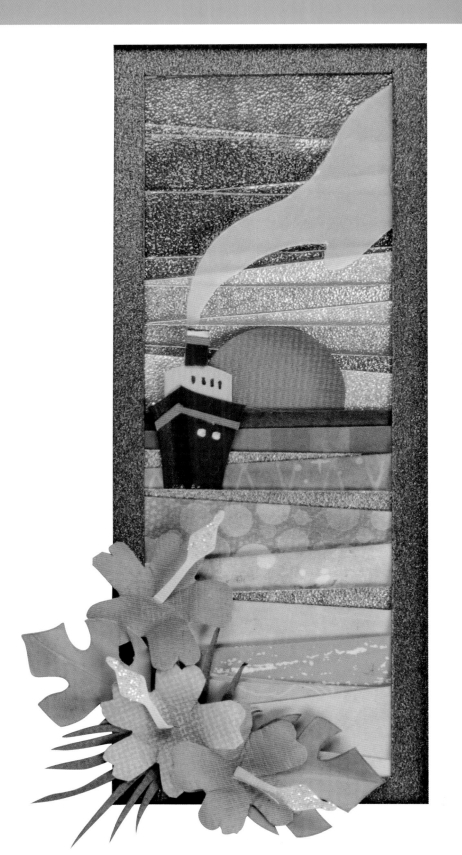

Introduction

Probably the best thing about iris folding is that it fuels my passion for beautiful papers. I really am a paper addict and have papers in every colour, pattern and finish you can imagine. I even feel upset sometimes if I have to use a particularly nice piece as I don't really want to cut it! This addiction takes up all my spare time and has filled at least one room in the house, but at least it is harmless and not too expensive. Iris folding allows you to show off beautiful papers in a gorgeous swirl of folded layers that will not fail to impress, and it is not that difficult when you know how.

Iris folding takes its name from the spiral pattern made by the overlapping metal leaves that make up the iris in the lens of a camera. Traditional iris-folded designs still resemble a simple spiral, but more advanced and contemporary techniques bear little similarity to this original pattern. The common factors in any iris-folded design are that the pattern is worked from the back over an aperture cut into card, and it involves using layers of folded strips of paper.

This book includes basic iris folding techniques to get you started, and some more advanced techniques with different folding methods for you to progress on to. Seasoned crafters as well as beginners will therefore find plenty in this book to challenge and inspire them.

A selection of eight tear-out papers is included at the back of the book, which I have designed especially for the projects featured. The only other things you need are some basic craft supplies – glue, card and tracing paper – so there is nothing to stop you from iris folding straightaway!

Michelle

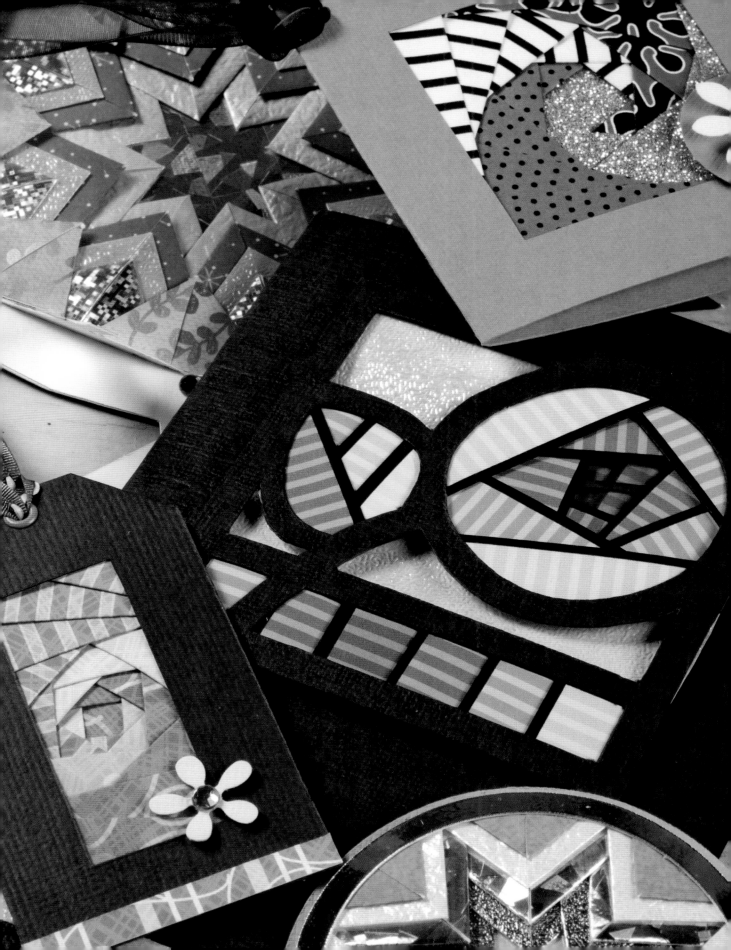

Materials & equipment

One of the best things about iris folding is that no specialist materials or equipment are needed and a simple iris-folded card can be made out of a few scraps of paper, some card, glue and a handful of basic tools that you will probably already have at home such as a pencil, ruler, craft knife and cutting mat. All the other materials and tools used to make the projects are easily available from your local art or craft store or via the internet.

Papers

Any paper can be used to create iris-folded designs, and you may already have many that will be suitable. Papers with a small pattern are better as the sections that are visible are small and a larger pattern will get lost. Make sure that your paper is thin enough to fold cleanly and easily; if the paper will not hold its fold, try a different one. Bulky handmade papers can be used, but will create a very different look.

For a typical design you will need less than an A6 sheet, so iris folding is ideal for using up small scraps of paper. Magazine pages and junk mail can also make some really interesting designs. Iridescent and metallic papers with a riven finish produce particularly nice results, or try origami papers that have lovely small patterns, metallic prints and are designed to be folded. There is no need to buy specialist packs of iris folding papers – these are just collections of patterned papers laid out in strips ready for cutting. It is very easy and less wasteful to cut your own strips as and when you need them. This also allows you to use the larger pieces of matching paper to make mounts and other embellishments for your iris-folded creations. You will also need a selection of coloured, iridescent and metallic papers; details of these are provided in the materials lists at the start of each project.

Supplied papers

A selection of exclusive papers that I have designed myself are supplied at the back of this book, so you can start creating the iris-folded designs featured in the projects straightaway. To use, simply tear the papers from the book along the perforations.

The width of each coloured section varies depending on how much is needed for each project. Also, with the exception of the Art Nouveau design (page 34), the papers are not divided into strips of a set width, as you may like to use the papers for other embellishments or to vary the width of strip you cut.

You will be able to make at least eight individual projects from the papers included; should you need more, all the designs, together with a further sixteen variations, are published in *Michelle Powell's Iris Folding Papers*, available from Search Press. Details are provided on page 4.

Opposite: A selection of papers and cards showing the variety of types, colours and designs you can use for iris folding.

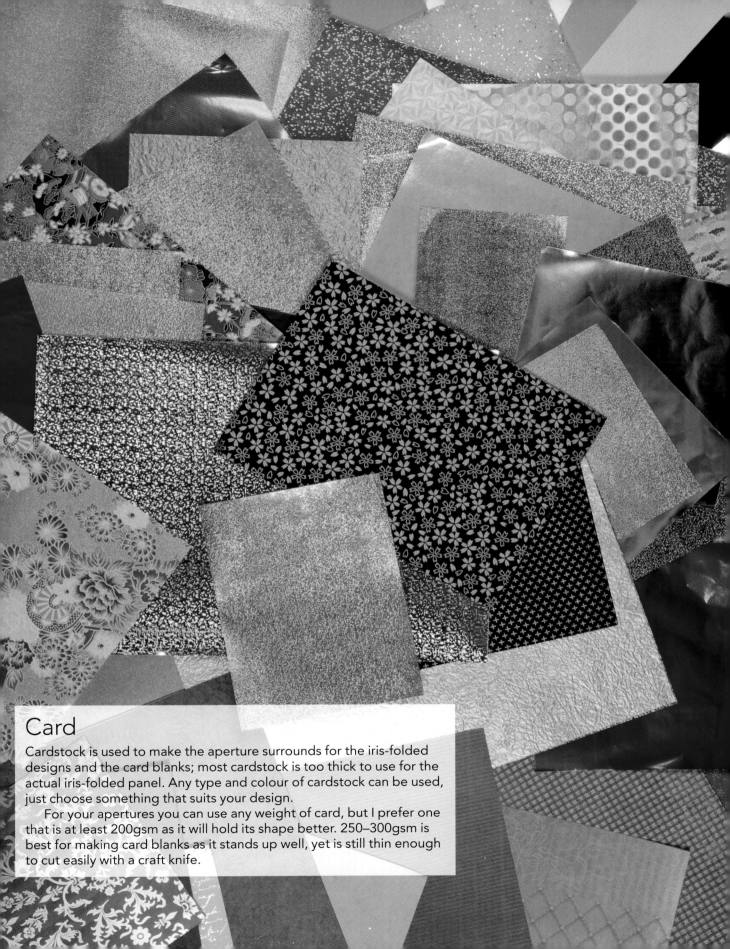

Card

Cardstock is used to make the aperture surrounds for the iris-folded designs and the card blanks; most cardstock is too thick to use for the actual iris-folded panel. Any type and colour of cardstock can be used, just choose something that suits your design.

For your apertures you can use any weight of card, but I prefer one that is at least 200gsm as it will hold its shape better. 250–300gsm is best for making card blanks as it stands up well, yet is still thin enough to cut easily with a craft knife.

Embellishments

With so many beautiful embellishments available to buy in craft stores, it is very tempting to go to town adding extra bits and pieces to your iris-folded designs, but in this case less is definitely more. I like to keep additional embellishment to a bare minimum and let the iris-folded design be the main feature of the card; the projects in this book are so intricate that you hardly need any further decoration at all.

A little ribbon with a simple pattern on it or a few gemstones look particularly pretty and do not overpower the design. For a professional look try adding eyelets to tag holes and a few dots of glitter for added sparkle. To bring your hand-cut or punched embellishments to life, just add a little chalking to the edges. Use solid coloured chalks for shading and iridescent chalks to add highlights and a pretty pearl sheen.

Pearlescent chalks give a gorgeous, shimmery finish to your craft makes.

Just some of the wonderful shop-bought embellishments you can use to add a finishing touch to your designs.

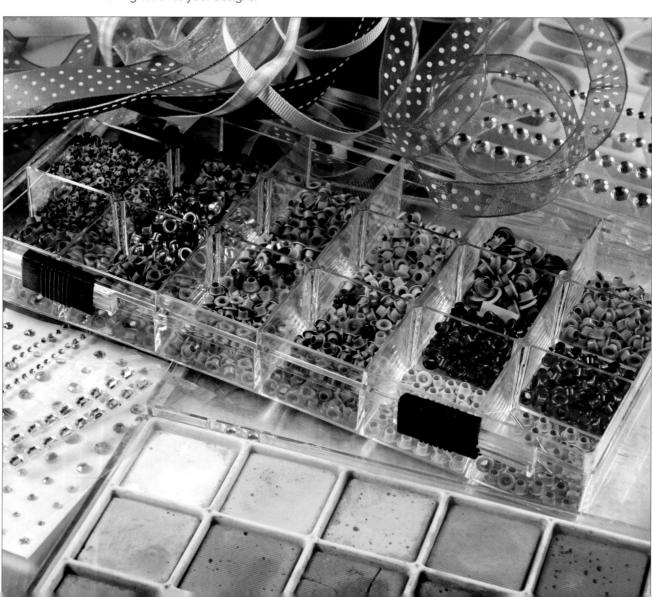

Other tools and equipment

The main tools needed for iris folding are all craft-box basics: a **pencil**, **pencil eraser** and **tracing paper** for transferring designs and marking measurements on pieces of card and paper (a **white pencil** is used for marking darker card or paper); a **ruler** for drawing straight lines and measuring and cutting strips (one with parallel black lines printed along its length is ideal for aligning edges); a **craft knife** and **cutting mat** for cutting apertures, paper strips and hand-cut embellishments; **adhesive putty** for fixing tracing paper in place while tracing, and the aperture in place on the template while the iris-folded design is being worked; **craft punches** for creating your own embellishments or punching small tags to decorate finished items; a **hole punch** for punching the hole in the top of tags so that **eyelets** can be set using an **eyelet setter** and **hammer**; various **ball-tipped styluses** and **embossing tools** for scoring paper before folding and, along with a base of **rigid foam**, for burnishing embellishments on to the back to give them more shape; **double-sided tape** or **3D foam pads** for fixing embellishments or background paper in place; **double-sided adhesive sheet** or **wide double-sided tape** for covering the back of your finished iris-folded designs to help fix them in place (if you cannot get full sheets, use several strips of the widest double-sided tape you can find); **glue roller** for fixing the folded strips that make up the design in place (alternatively use a glue stick or all-purpose glue, but a roller is neater and easier); **all-purpose glue** for attaching embellishments; and a **paintbrush** for painting blank boxes. In addition, you will need a **black pen** for adding eyes to some of the designs in this book and **wire cutters** for cutting the chain embellishment on the little black bag card on page 22.

Other tools and equipment.

Iris folding does not have to be limited to card making; use iris-folded panels on gift boxes or to frame a special design for your wall. Blank papier-mâché boxes are widely available and are easy to paint or cover. Deep box frames are useful for presenting your work if you have three-dimensional embellishments on your designs.

Techniques

The basic techniques of iris folding are more simple than you would imagine, given the spectacular effects you can achieve. Here I have shown how to fold and score card to make a greetings card; transfer an iris folding design from a template to a piece of card; cut and fold the paper strips used to create the design; make a key to help you implement your design; and make templates of your own, which will allow you to create your own iris-folded designs.

Folding and scoring card

Create a card blank from any piece of thin card by folding it in half. Always measure and score your card before folding. A card with a weight of between 150 and 300gsm is ideal for greetings cards.

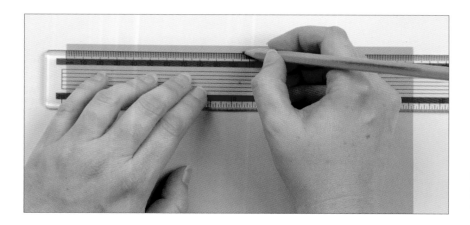

1. Lay a ruler across the top of the piece of card and mark the centre point with a pencil. Do the same across the bottom.

2. Align a ruler on the two pencil marks and score the centre line using an embossing tool.

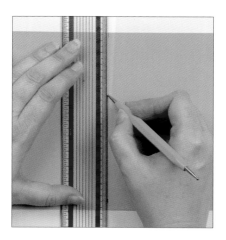

3. Fold the card along the score line, align the edges and press firmly along the fold with your fingernail.

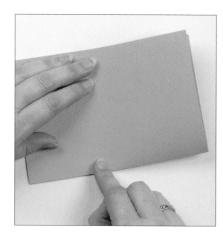

Transferring designs

The first stage of all iris-folded designs is to transfer the outline for the design to a piece of card, cut it out to create an aperture and then secure a folding template face down on top of it. You can trace the iris folding templates either directly from this book or from photocopies.

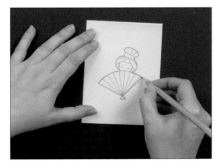

1. Place a sheet of tracing paper over the design and trace around the outline only using a pencil.

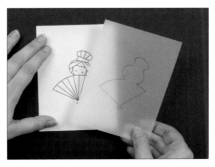

2. Lift off the tracing.

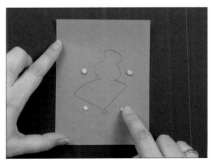

3. Leave the design face-upwards, and attach four or five small pieces of adhesive putty around the outside of the design.

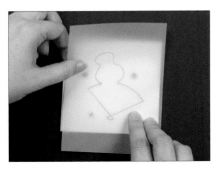

4. Turn the tracing over and attach it to the front of your card using the adhesive putty.

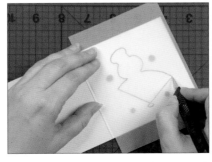

5. Open out the back of the card and place the card on a cutting mat. Cut around the outline using a craft knife, cutting through both the tracing paper and the card.

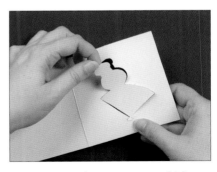

6. Remove the tracing and lift out the centre of the design.

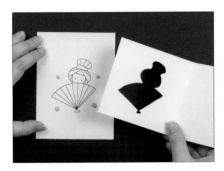

7. Place small pieces of adhesive putty on the front of the original design.

8. Position the card face-down over the design so that the cut-out outline aligns with it exactly, and attach the two together using the adhesive putty.

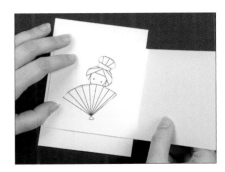

Cutting and folding paper strips

To create a successful iris-folded design you need to be able to cut and fold your paper strips accurately. The width of strip you need depends on the design and the size of the section to be covered, though 2cm (¾in) wide strips suit most designs. These can be cut down if necessary for more intricate work.

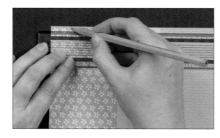

1. Lay a ruler across the top of the sheet of paper, and mark 2cm (¾in) from the edge using a pencil. Mark the same distance along the bottom of the sheet.

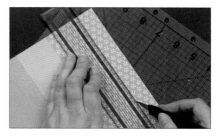

2. Working on a cutting mat, join the two marks with a ruler and run a craft knife along the edge to trim off the paper strip.

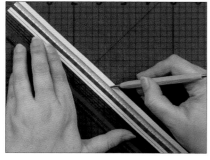

3. Turn the paper strip over, place the ruler approximately two-thirds of the way across it, and score a line along the edge of the ruler.

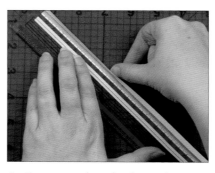

4. Run your thumb along the paper, underneath the narrower side of the strip, to fold it upwards, therefore emphasising the fold.

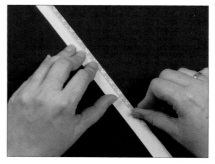

5. Remove the ruler, and crease the fold firmly.

Making a key

Iris-folded designs usually involve up to five different papers, each indicated by a different symbol on the template. A key is a good way of remembering which symbol represents which type of paper.

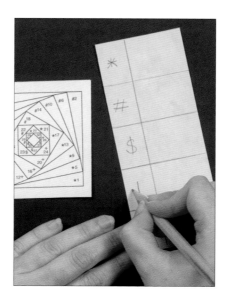

1. Mark a piece of scrap card into five equal rows and two columns, one wider than the other. Copy the symbols from the iris folding template into the left-hand (narrow) column (in this book a maximum of five symbols are used).

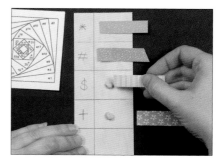

2. Cut a scrap of each kind of paper, and attach it to the key opposite the appropriate symbol using adhesive putty. (You can create different looks by altering the paper you assign to each symbol.)

Making your own template

Once you have gained some experience of iris folding, you will almost certainly want to create iris-folded designs of your own. Most require you to cut a specific aperture shape, but you can also fit a basic template design to your own aperture. Try using craft punches, die cuts or stencils to create a shaped aperture, then trace your own design using the basic iris folding template on page 63.

1. Cut out your chosen design from card (here I have used a craft punch).

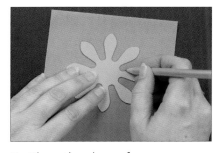

2. Place the shape face-up on a piece of tracing paper and draw carefully round the edge in pencil.

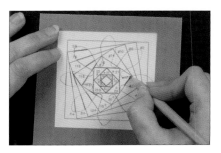

3. Lay the design over the iris folding template, either centrally or slightly off-centre depending on the effect you wish to achieve. Trace over all the lines that fall within the design.

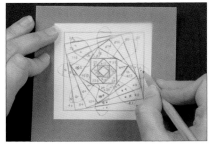

4. Transfer the numbers to each section that lies within the design, starting with the lowest number and working upwards.

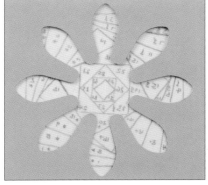

5. Place the traced template face down on your work surface. Attach small pieces of adhesive putty to the front of the card and place it face down on top of the template, securing it with the putty. Make sure the cut-out shape is aligned accurately with the template.

Tip

As the numbers on the template are now face down, you may wish to write them in correctly on the side facing you before attaching the paper strips.

6. Attach the paper strips in the normal way, starting with the lowest-numbered sections (you may not necessarily start from section 1) and ending with the highest.

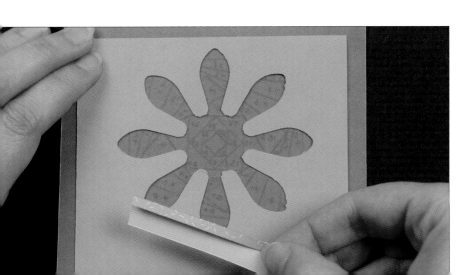

Pretty Pink Parcel

This simple greetings card uses a basic square iris-folded design created in a parcel-shaped aperture. This is iris folding in its most traditional form and creates a swirling image using four different papers that resembles the iris in a camera lens.

The pretty parcel design is particularly useful for greetings cards as it suits most types of occasion. The delicious pink and brown shades make a very feminine birthday card, and you could even add the recipient's name or age to the tiny tag. Use paper in shades of browns and golds for a more masculine card, or try white textured and iridescent papers with silver embellishments to make a lovely wedding card. Change the flower to a holly sprig and use greens and reds for a Christmas variation.

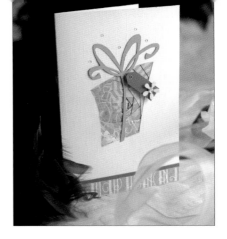

You will need

- Cream card blank, 10.5 x 15cm (4¼ x 6in)
- Cream, brown and dark pink cardstock
- Iris folding papers (pages 65 and 67)
- Small pink eyelet
- One large and five small pink self-adhesive gemstones
- 3D foam pads and glue roller
- Double-sided adhesive sheet
- Adhesive putty, pencil and tracing paper
- Scissors, ruler, craft knife and cutting mat
- Small hole punch
- Small flower punch
- Eyelet setter and hammer
- Double-sided tape
- Templates on page 56

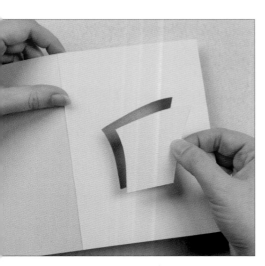

1. Transfer the outline for the design to the front of the card blank and remove the cut-out shape.

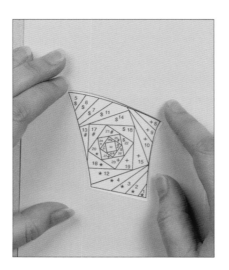

2. Open out the card, and position it face-down over the iris folding template. Secure it using adhesive putty.

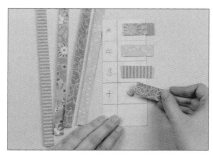

3. Cut and fold four paper strips, and use short pieces to create a key.

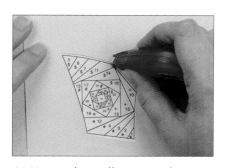

4. Use a glue roller to apply a strip of glue to the card around the outside of the aperture. Keep the glue as close to the edge of the aperture as possible.

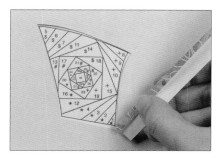

5. Check the symbol on section 1 and refer to your key to select the correct paper. Roughly line up the folded edge of the first strip with the first section on the template to see how long it needs to be.

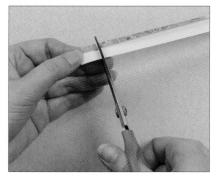

6. Cut off a length of strip slightly longer than required.

7. Attach the strip to the card, aligning the fold with the line on the template at the edge of section 1.

8. Place a line of glue along the back of the first strip.

9. Cut and attach the second strip, aligning it with the edge of section 2.

10. Glue on the third and fourth strips in the same way. Change paper for the fifth strip following the key you made earlier.

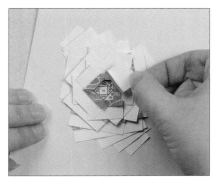

11. Complete the design, following the numbers and symbols on the template and referring to the key as you work. Apply more glue as necessary.

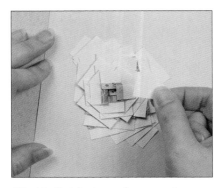

12. To finish, lay a flattened-out strip over the hole in the centre to complete the design.

The back of the completed design.

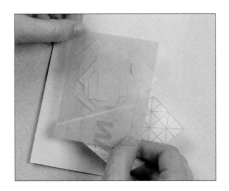

13. Cut a piece of double-sided adhesive sheet slightly larger than the design, peel off one side and lay it sticky-side down over the back of the paper strips. This ensures that everything is stuck down firmly.

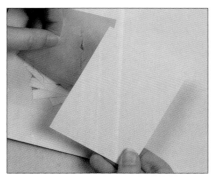

14. Peel off the other side of the adhesive sheet and cover the back of the design with a piece of matching cardstock to neaten the inside of the card.

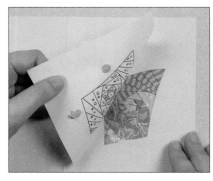

15. Turn the card over and remove the template, revealing the iris-folded design.

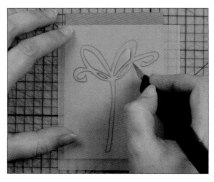

16. Transfer the design for the card embellishment on to tracing paper and use this to cut out the bow shape from dark pink card.

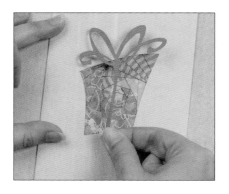

17. Apply all-purpose adhesive to the back of the bow shape and attach it to the front of the card.

18. Cut a tag shape from a small piece of brown card using the template provided, and make a small hole in the top using a hole punch.

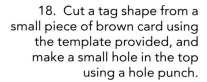

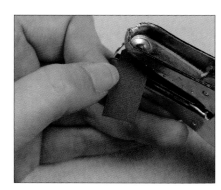

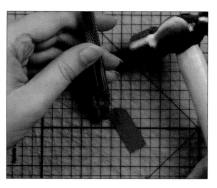

19. Insert a tiny pink eyelet through the hole and set in place using an eyelet setter and hammer.

20. Attach the tag to the card using two 3D foam pads.

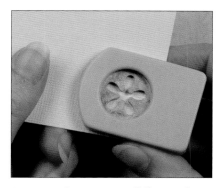

21. Punch out a small flower from cream card.

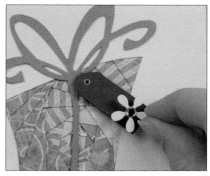

22. Attach a pink gemstone to the centre of the flower, and attach the flower to the tag using a 3D foam pad.

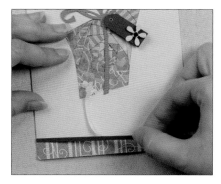

23. Attach a wide, patterned paper strip and a narrower, brown card strip along the bottom of the card using double-sided tape.

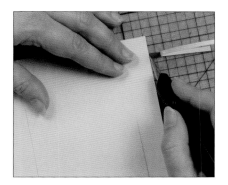

24. Turn the card over and trim off the ends of the paper strips.

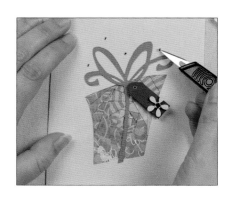

25. Finish by attaching some tiny, self-adhesive gemstones around the top of the design.

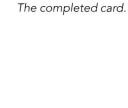

The completed card.

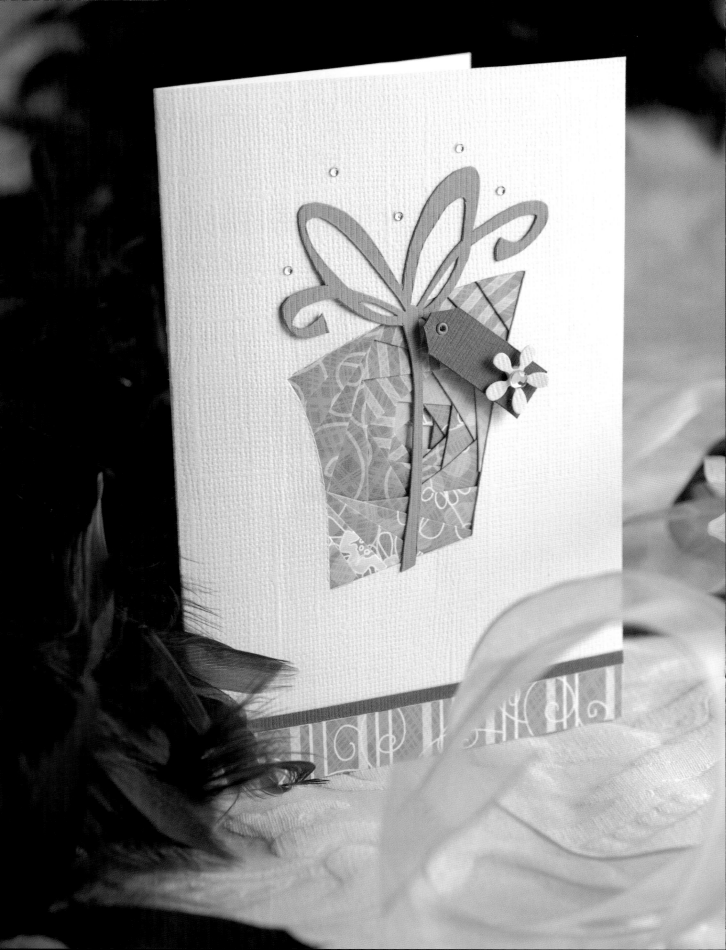

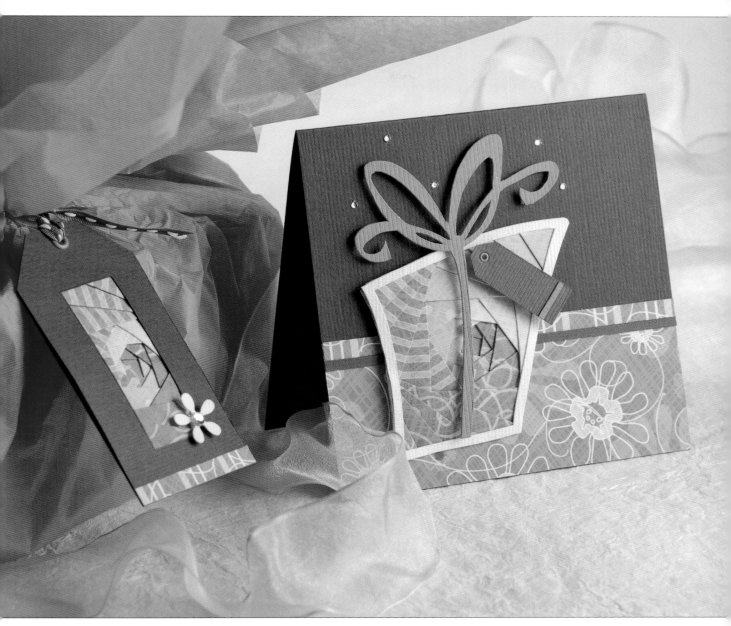

Above: *The same design can be adapted to make a whole range of greetings cards and matching gift tags. Use different combinations of paper strips to vary the iris-folded design, and adapt the basic iris folding template given on page 63 to make the gift tag. To create a narrow border around your iris-folded panel, complete the iris folding on a large piece of card then carefully trim away the surrounding card and folded strips. The iris-folded shape can then be mounted on a contrasting colour, using 3D foam pads for extra dimension. The simple matching tag is based on a traditional iris-folded design (see page 15 for instructions on how to create your own template).*

Left: *The completed project.*

Little Black Bag

The unusual three-folded layout of this greetings card makes an interesting basis for an iris-folded design. The design is constructed in the normal way, with the aperture worked into the shape of the folded card to produce a three-dimensional effect. The green and black give the card a sophisticated look, and as always it is worth experimenting with different colours.

 For a more professional finish, spend a little extra time cutting a backing sheet to cover the back of the iris panel, that always looks untidy however neatly you work.

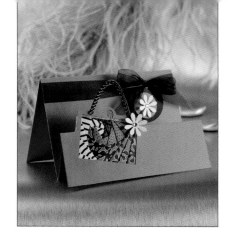

You will need

- Green card, 30 x 15cm (12 x 6in)
- Green, black and white cardstock
- Silver glitter paper
- Iris folding paper (page 69)
- Black ribbon
- Short length of black chain
- Silver eyelet
- 2 silver self-adhesive gemstones
- 3D foam pads, glue roller and all-purpose glue
- Double-sided adhesive sheet
- Adhesive putty, pencil and tracing paper
- Scissors, ruler, craft knife and cutting mat
- Small hole punch
- Flower and circle craft punches
- Eyelet setter and hammer
- Embossing tool
- Double-sided tape
- Wire cutters
- Template on page 56

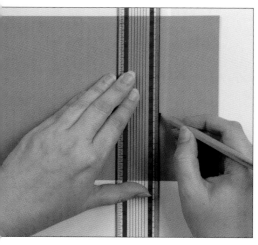

1. Divide the green card into three 10cm (4in) sections using a pencil and ruler. Divide the right-hand section into two 5cm (2in) sections.

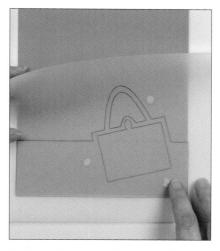

2. Turn the card through 90° so that the two 5cm (2in) sections are at the bottom. Trace over the handbag design provided on page 56 (see page 13), and attach the tracing face down to the card using adhesive putty, carefully aligning the edges of the design with the sides and base of the card.

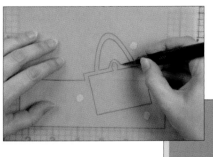

3. Place the card on a cutting mat and cut out the central part of the handbag and the area enclosed by the handle using a craft knife. Also cut round the top part of the handbag, down as far as the 5cm (2in) line.

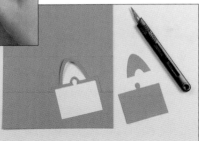

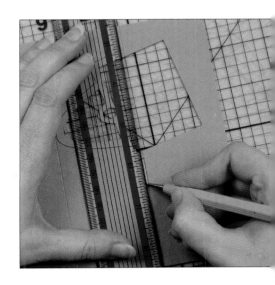

4. Remove the tracing, and score along each of the pencil lines on the card using an embossing tool. On the lower line, score only from the cut edge of the design outwards.

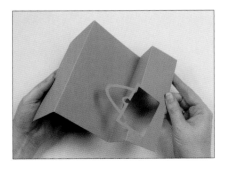

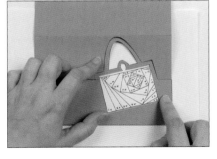

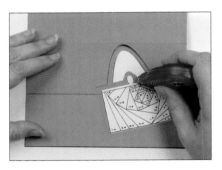

5. Fold the card as shown in the picture, so that the top part of the handbag is raised on the front of the card.

6. Turn the card over and attach it face down to the iris folding template using adhesive putty, aligning the template with the middle section of the handbag.

7. Apply glue around the outside of the handbag, not including the handle.

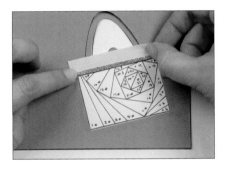

8. Cut four strips of patterned paper and one of silver glitter paper. Attach the silver glitter paper strip across the top of the handbag (this section is not numbered).

9. Make a key and begin to apply the remaining strips, starting with section 1.

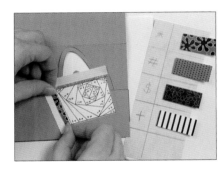

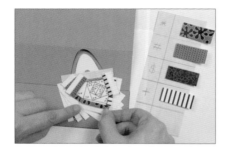

11. Complete the design by gluing a square of unfolded paper over the hole in the centre.

10. Continue to attach the paper strips, following the numbered sections consecutively, changing paper to match the symbols and applying more glue as required.

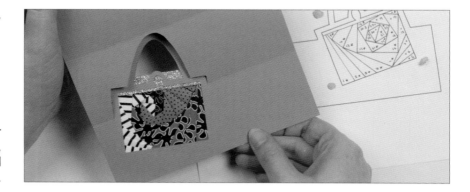

12. Turn the card over and remove the template, revealing the iris-folded design on the front.

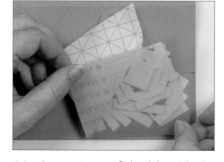

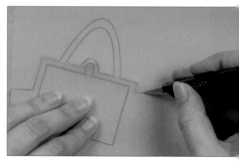

13. Working on a cutting mat, fold the card to bring the top of the bag forward, and trim off any excess paper using a craft knife.

14. Cut a piece of double-sided adhesive sheet to size, peel off one side and lay it sticky-side down over the back of the design. Trim off any excess if necessary.

15. Place the traced pattern face down on a new piece of green card, aligning the bottom edge of the design with the base of the card. Cut round the design, excluding the handle, using a craft knife.

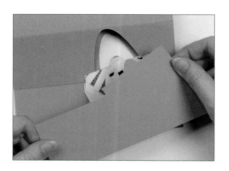

16. Apply more adhesive sheet to the left of the design. Remove the protective layer from both pieces of adhesive sheet and lay the cut-out card over the top to neaten the back.

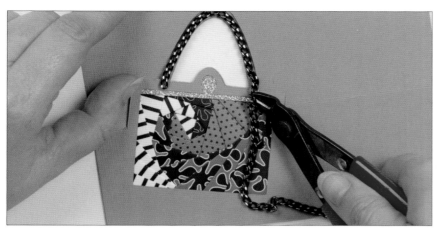

17. Apply all-purpose glue around the handle and attach the chain. Trim off the excess chain once it is attached using wire cutters.

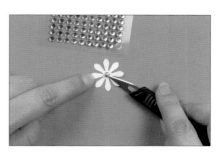

18. Punch a small flower, approximately 2.5cm (1in) in diameter, out of white card, and place a silver self-adhesive gemstone in the centre.

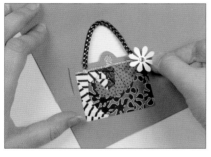

19. Attach the flower to the front of the card using a 3D foam pad.

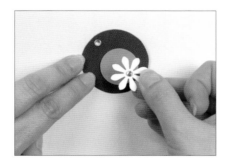

20. Punch a black circle, a smaller green circle and a second white flower out of card. Attach a silver gemstone to the centre of the flower as before, and set a silver eyelet through a hole in the top of the black circle using an eyelet setter. Glue the three elements together using 3D foam pads, placing them as shown in the picture.

The completed card.

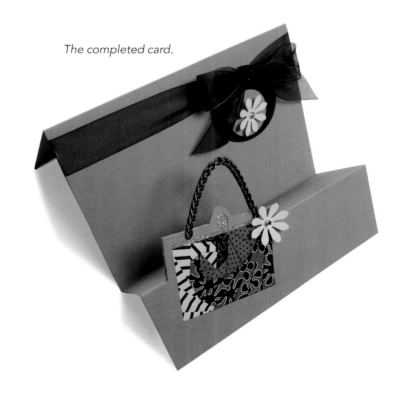

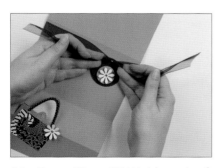

21. Cut a 60cm (23½in) length of black ribbon and wrap it around the centre section of the card. Thread both ends from the back through the eyelet in the circular tag, and tie them in a bow on the front of the card.

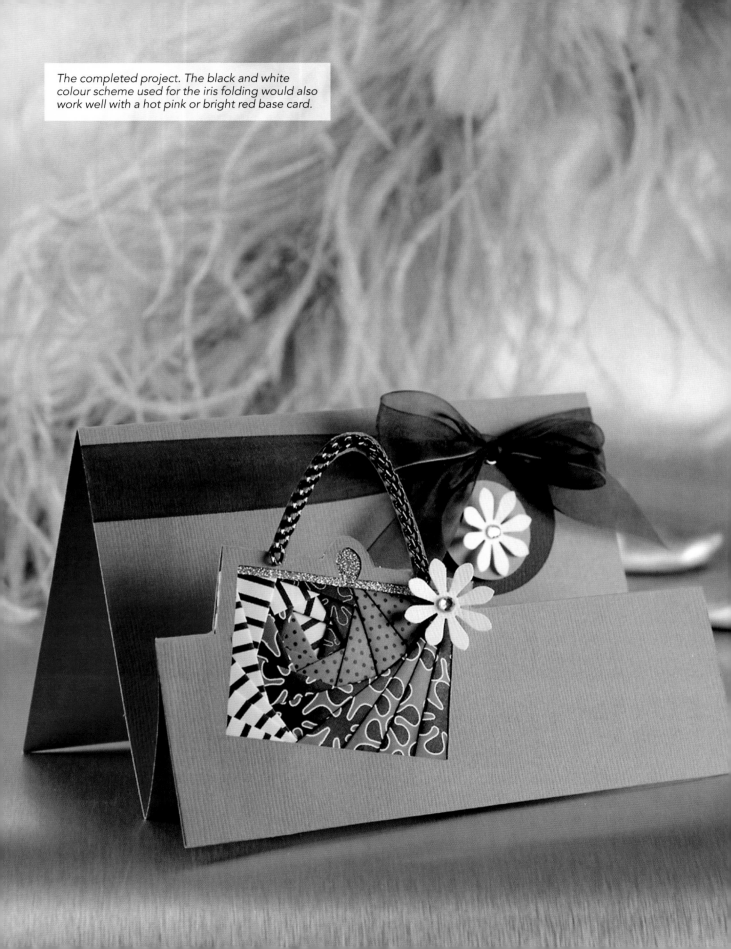

The completed project. The black and white colour scheme used for the iris folding would also work well with a hot pink or bright red base card.

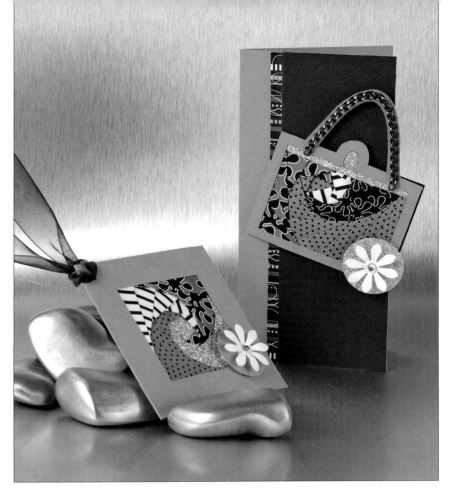

Left: Create a simpler card using the handbag design on a regular card blank. The papers have been used in a different order from the main project.

Below: Use the three-fold card style with pretty, pastel-coloured papers to create baby congratulations or Christening cards. The iris folding templates for the cute duck, teddy and pram designs are given on page 57. The papers are supplied on pages 71 and 73. Trace around the front face of the card as for the handbag card to create the neatening backing sheet.

If you want to make a taller card that folds vertically, similar to the pink duck design below, simply rotate the iris folding template image 90° when tracing the aperture shape on to the card. This can be done with any of the designs. Experiment on a scrap of card if you are unsure of the positioning.

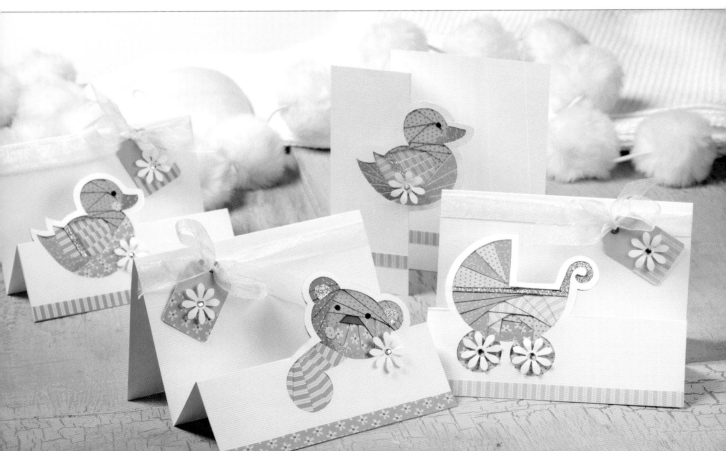

Poppy Landscape

This project introduces a slight variation on the traditional iris folding technique. Layers of folded paper are laid in only one direction, creating a natural landscape effect. You do not need a key for this project as nearly every strip of paper you use is different, and it is entirely up to you which papers you choose! There are therefore no symbols on the template either.

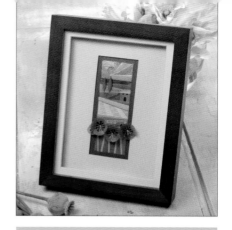

You will need

- Brown card, 7 x 15cm (2¾ x 6in)
- Green papers, some printed, in eight different shades
- Red and gold papers in four different shades
- Straw-coloured papers in two different shades
- Orange, green and yellow iridescent papers
- Cardstock in black, brown, cream, orange and green
- Variegated red vellum paper
- 3D foam pads, glue roller and all-purpose glue
- Double-sided adhesive sheet
- Adhesive putty, white pencil and tracing paper
- Scissors, ruler, craft knife and cutting mat
- Chalks, with crocodile-clip applicator and pompoms
- Stamen, 2.5cm (1in) and 2cm (¾in) circle craft punches
- Rigid foam
- Large-balled embossing tool
- Box frame
- Templates on page 57

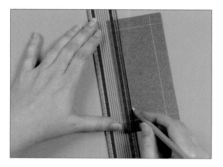

1. Using a white pencil and a ruler, draw a border 1.5cm (¾in) wide around the outside of the brown card.

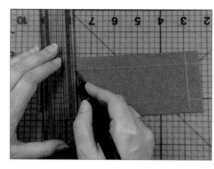

2. Working on a cutting mat, cut out the middle of the card using a craft knife.

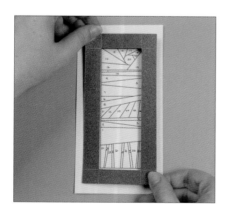

3. Use adhesive putty to attach the frame to the iris folding template, face down so that the pencil marks are facing upwards.

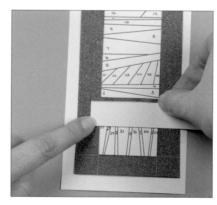

4. Cut a red paper strip approximately 2.5cm (1in) wide, fold over one edge and place it over the template with the folded edge aligned with the top of section 1.

Tip

If designing your own iris-folded landscape, remember that colours are darker and more faded in the background and more vivid and lighter in the foreground.

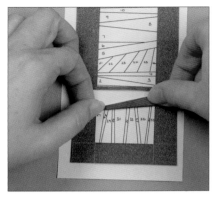 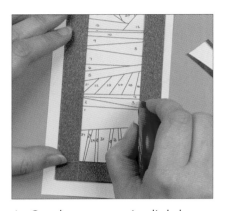 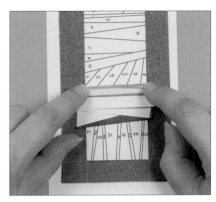

5. While holding it in the same position, fold up the lower edge at an angle so that the fold lies along the bottom of section 1.

6. Cut the paper strip slightly wider than the template, and run glue down the frame on either side of section 1.

7. Attach the double-folded paper strip to section 1. Continue attaching single-folded strips to sections 2, 3 and 4, using red and gold papers.

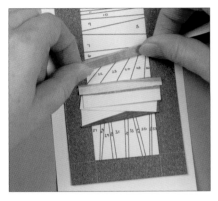 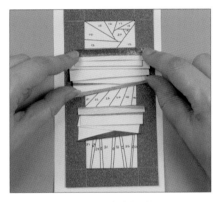 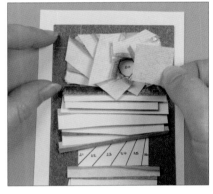

8. Attach a green, double-folded strip to section 5.

9. Attach single-folded strips to sections 6 to 11 using a range of green papers.

10. Make the iris-folded sun using alternate yellow and pale orange iridescent papers, gluing a small square of dark orange iridescent paper over the centre to finish.

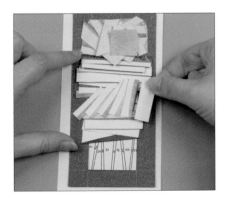

11. Using alternate dark and light straw-coloured strips, work your way across the vertical sections numbered 21 to 26.

12. Work across sections 27 to 37 in the same way, alternating dark green printed and light green iridescent strips to form the poppy stems.

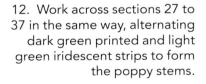 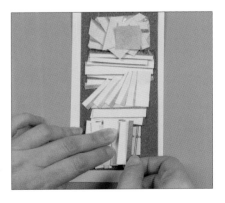

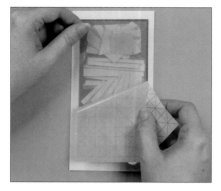

13. Cut a piece of double-sided adhesive sheet to size, peel off one side and lay it sticky-side down over the back of the design.

14. Remove the template, revealing the completed design underneath.

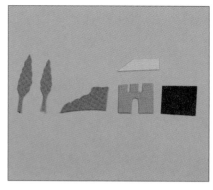

15. Cut out the shapes used to decorate the landscape from scrap pieces of card. Use the templates on page 57.

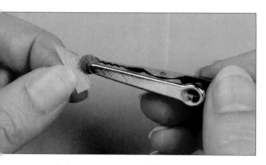

16. Using a small pompom held in a crocodile-clip applicator, apply orange chalk to the top and sloping side of the roof, and green chalk to one side of the trees and foliage. This gives them a three-dimensional appearance.

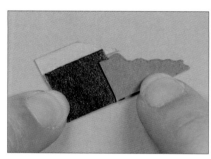

17. Glue the front and back parts of the house together, add the roof, then turn the house over and attach the foliage.

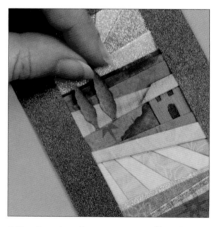

18. Apply all-purpose adhesive to the back of the house and the foliage (not the roof) and the lower parts of the trees, and attach them to the landscape. Conceal the bases of the shapes between the folded strips.

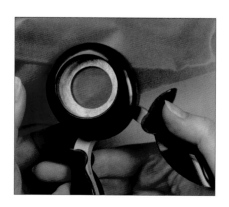

19. Punch five circles from variegated red vellum to make the poppies – three approximately 2.5cm (1in) in diameter, and two 1.5cm (¾in) across.

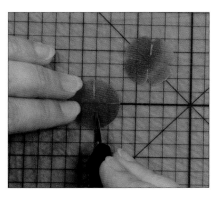

20. Working on a cutting mat, use a craft knife to form each flower into four petals.

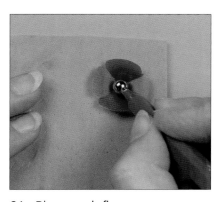

21. Place each flower on a piece of rigid foam, and burnish the centre using a large-balled embossing tool by pressing down firmly while moving the tool in a circular motion.

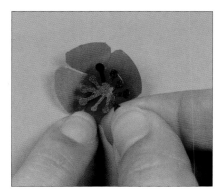

22. Punch the stamen shapes out of black card and glue them in the centres of the flowers using all-purpose adhesive. Trim the stamen for the smaller flowers.

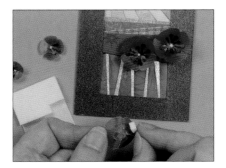

23. Attach the poppy flowers to the tops of the stems using 3D foam pads.

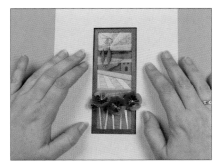

24. Cut a piece of card as a mount for your picture. Cut it to the correct size for your chosen frame, with an aperture of 5 x 13cm (2 x 5in). Attach the mount using 3D foam pads.

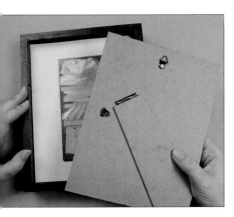

25. Place the mounted picture face down in the frame and attach the back.

The completed, framed picture.

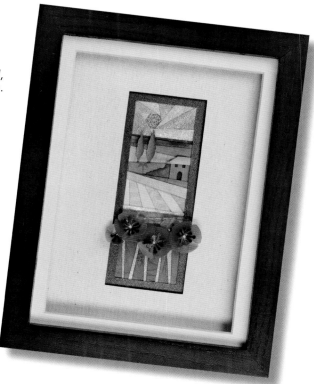

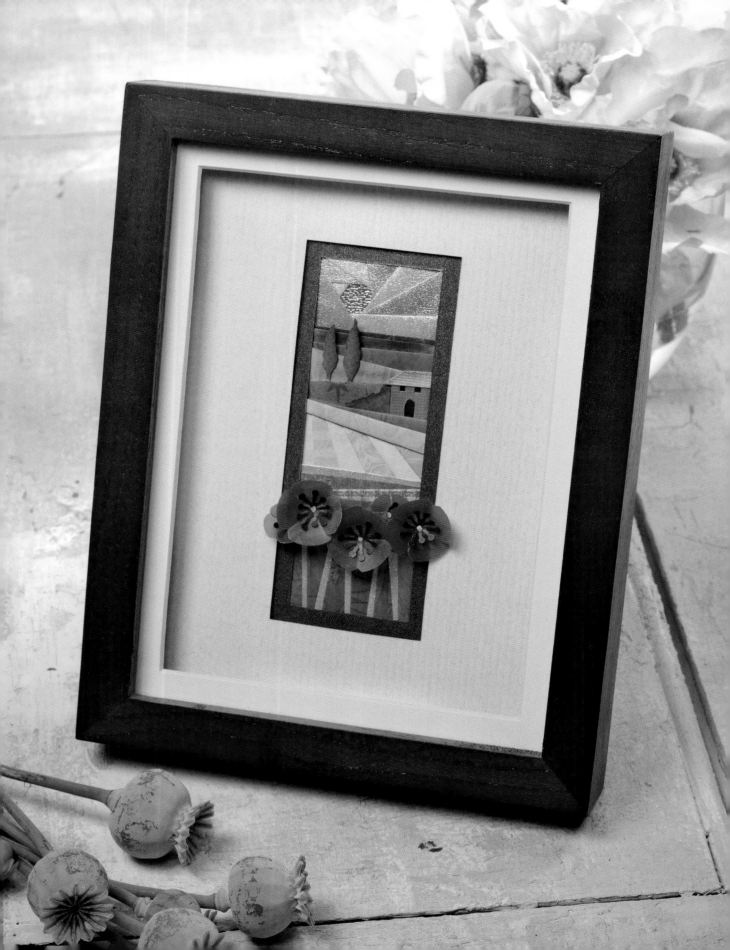

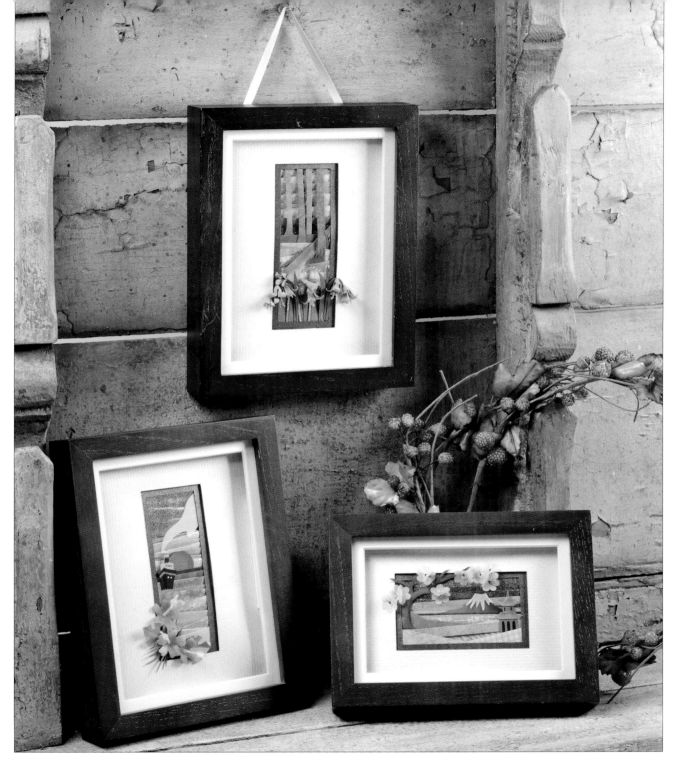

This is an excellent technique for creating your own iris-folded designs as you can use your artistic licence to invent all sorts of landscapes simply by varying the positions and colours of the paper strips. The Tropical Cruise picture uses iridescent paper to create a sunset at sea, with punched tropical flowers and leaves used as decoration. The Bluebell Wood design has layers of purples and blues covering the forest floor. The bluebells are made from small, punched daisies, rolled up to resemble bluebell flowers. The Japanese Scene includes a hand-cut pagoda, Mount Fuji and cherry blossom punched from pale pink vellum. Templates for each of these variations are provided on pages 58–59.

Art Nouveau Trinket Box

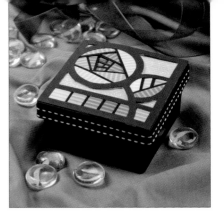

Inspired by the work of Scottish artist and architect Charles Rennie Mackintosh, this rose design uses specially printed iris folding strips to create a stained glass effect. You will find these strips on pages 75 and 77. To create your own, simply cut and fold strips of the paper you wish to use, then use a wide marker pen and a ruler to draw a thick black border along each folded edge. For best results turn the ruler upside-down when drawing the line to avoid smudging the ink.

No symbols are included on the templates; instead simply position the coloured papers where appropriate to the design. For the flowers, use the lightest shades at the edges, and progressively darker ones towards the centre.

You will need

- Iris folding paper (page 75)
- Black cardstock
- White iridescent paper
- Square blank gift box
- Narrow black and white ribbon to cover the edge of the box lid
- Black poster paint and paintbrush
- Glue roller and all-purpose glue
- Double-sided adhesive sheet
- Double sided tape
- Adhesive putty, pencil and tracing paper
- Scissors, ruler, craft knife and cutting mat
- Template on page 58

1. Trace the design on to tracing paper and secure it face down on a piece of black card using adhesive putty. Working on a cutting mat, cut out the shapes within the design using a craft knife.

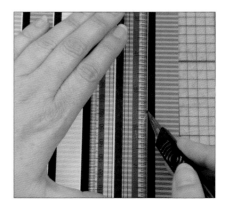

2. Cut out the paper strips along the white lines.

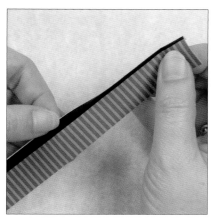

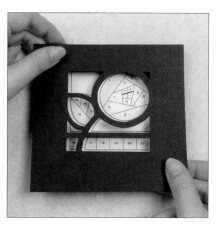

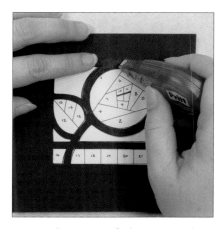

3. Score and fold the paper strips approximately two-thirds of the way across the black border, so that when they are folded there is a narrow black border along the folded edge.

4. Turn the cut-out design over and secure it face down to the iris folding template, aligning the two carefully. Secure it in position using adhesive putty.

5. Apply a ring of glue around the flower.

7. Continue adding the paper strips to the flower head, using progressively darker tones of lilac as you work towards the centre. Stop when you have completed section 9.

6. Using the palest lilac paper, attach the first strip to section 1.

8. Cut a thin strip of black card and attach it across the thick line in the centre of the flower. Glue it at either end.

9. Complete the centre of the flower by adding the final two strips to sections 10 and 11.

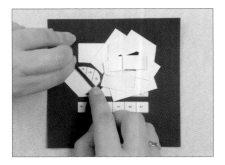

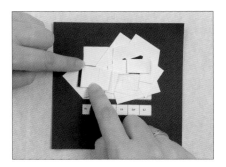

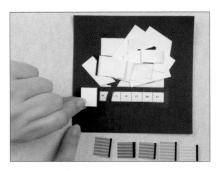

10. Apply glue around the outside of the leaf and attach the darkest green strip to section 12.

11. Attach progressively darker shades of green to sections 13 to 15 to complete the leaf.

12. Attach paper strips in different shades of lilac to the panel across the bottom of the design.

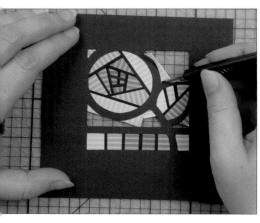

13. Turn the design over and remove the template. Working on a cutting mat, trim off any excess paper using a craft knife.

14. Trim off the sides of the black card, leaving a 0.5cm (¼in) border around the design.

15. Cut a piece of white iridescent paper to fit just within the black border. Apply a layer of all-purpose adhesive to the back of the design, and glue the paper face down over the top.

16. Cut a piece of double-sided adhesive sheet to size, peel off one side and lay it sticky-side down over the back of the iridescent paper.

17. Paint the outside of the box and lid using black poster paint. Allow the paint to dry.

18. Attach the black and white ribbon around the edge of the lid using double-sided sticky tape.

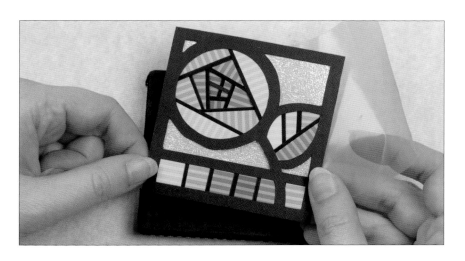

19. Remove the protective layer from the adhesive sheet covering the back of the design, and attach the design to the box lid.

The completed box.

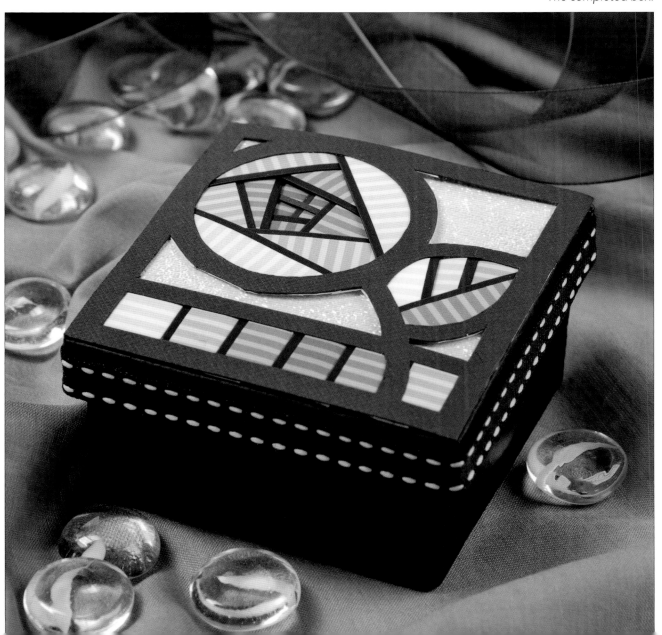

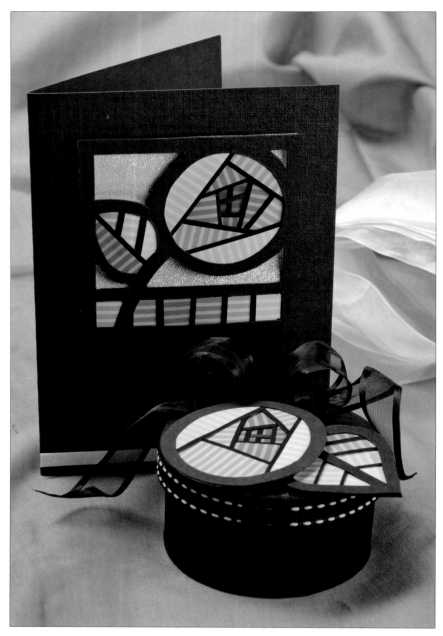

Create a matching greetings card using the same iris-folded design mounted on a black A6 card blank. Add a single narrow strip of paper to the base to complete the card. Alternatively, use the leaf template and the circular flower on the large gift bag template on page 60 to decorate the top of a small, round gift box.

Pretty pink shades have been used to make these variations on the rose design. The iris folding templates for all of the designs shown here are on pages 59–60 and the pink and green iris folding paper can be found on page 77.

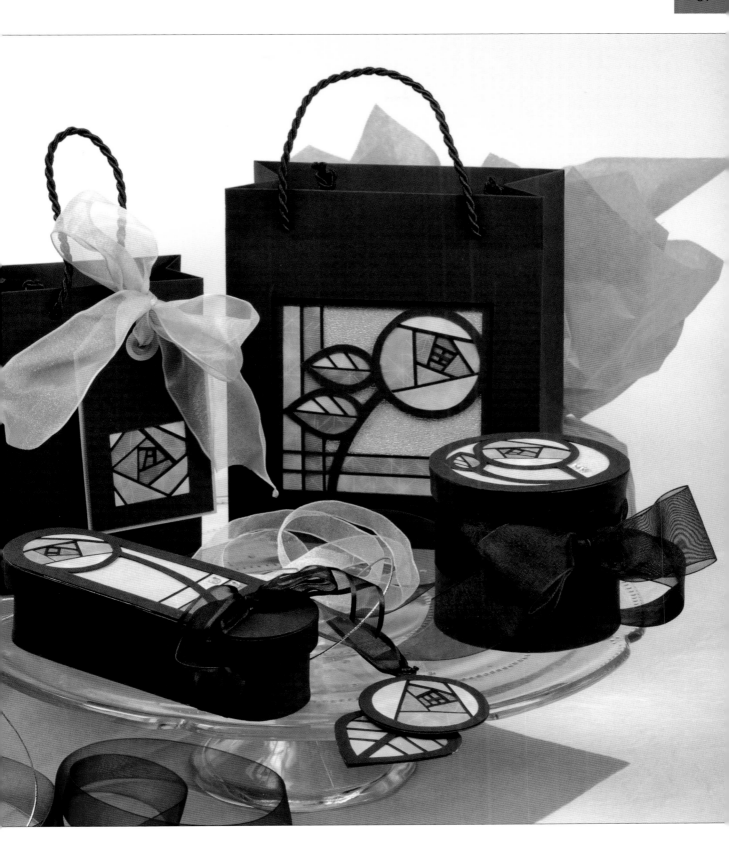

Sparkly Fairy Card

This pretty greetings card would be ideal for a young girl's birthday and is charming enough to be framed to go on her bedroom wall!

It uses a clever technique to ensure that every part of the design is made from iris folding paper strips. For example, the fairy's hair is made up of individual paper strips, the pleats in her skirt are created by alternating two different-coloured paper strips, and the delicate pattern on her beautiful, iridescent wings is made by simply following the pattern on the template. This technique takes traditional iris folding one step further, and opens up a whole host of new design possibilities.

You will need

- White card blank, 13 x 13cm (5 x 5in)
- Iris folding paper (page 79)
- White iridescent paper
- Silver glitter paper
- Cardstock in white, pale pink and purple
- Silver self-adhesive gemstones
- Glue roller and all-purpose glue
- Double-sided adhesive sheet
- Double-sided tape
- Adhesive putty, pencil and tracing paper
- Scissors, ruler, craft knife and cutting mat
- Chalks, with crocodile-clip applicator and pompoms
- Fine-nibbed pen
- Small star craft punch
- Template on page 62

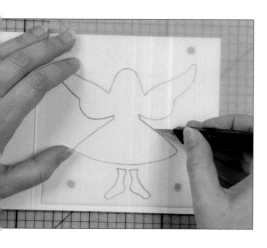

1. Trace over the fairy design provided on page 62 (see page 13) and attach the tracing to the front of the card blank using adhesive putty. Working on a cutting mat, cut out the design using a craft knife.

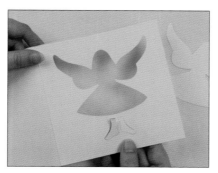

2. Remove the cut-out pieces of card.

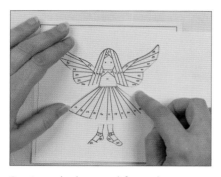

3. Attach the card face down over the iris folding template using adhesive putty. Ensure the template is aligned accurately with the cut-out design.

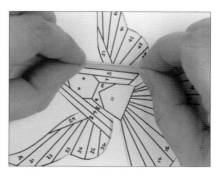

4. Make a double-folded strip of yellow paper for section 1 – fold over one edge of the paper strip, align the folded edge with the left-hand side of section 1, then fold over the other edge to align with the right-hand side of section 1.

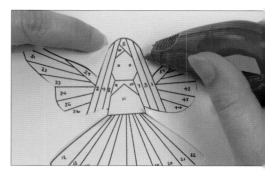

5. Apply a line of glue around the top of the fairy's head, taking it down to just below the ends of her hair.

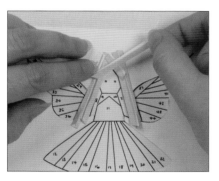

6. Glue the double-folded strip to section 1. Repeat for section 2, then complete sections 3 to 6 using single-folded strips of the same colour.

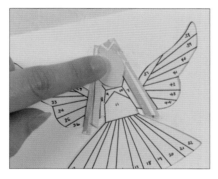

7. Cut out the head and neck shapes from pale pink card using the templates provided. Apply glue to the paper strips around the outside of the head, and attach the head shape.

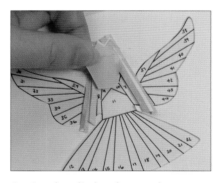

8. Apply a little glue to the base of the head and attach the neck shape.

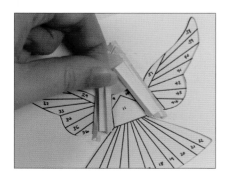

9. Attach the two remaining single-folded strips of hair – sections 7 and 8.

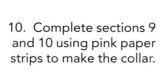

10. Complete sections 9 and 10 using pink paper strips to make the collar.

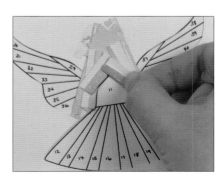

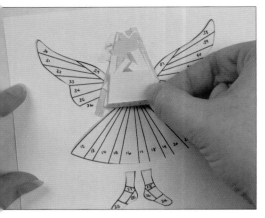

11. For section 11 (the fairy's body) cut a wide strip of purple dotted paper, and fold up the bottom. Glue it in place.

12. Begin the skirt. First, apply glue around the outside of the skirt, then attach the first strip to section 12 using floral-patterned pink paper.

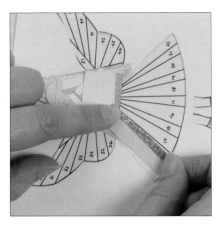

13. Attach the next strip – to section 13 – using silver glitter paper.

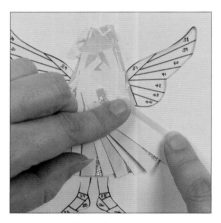

14. Complete the remaining sections of the skirt, using alternately pink floral and silver glitter paper.

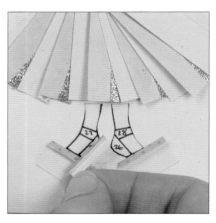

15. Apply glue around the fairy's legs and feet, and attach purple dotted strips to the toes and then the sides of her shoes.

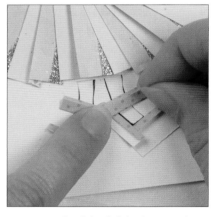

16. Use double-folded strips for the ankle straps.

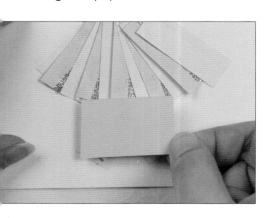

17. Cut a piece of pale pink card to cover the fairy's feet and legs. Apply glue to the back of the design and attach the pale pink card.

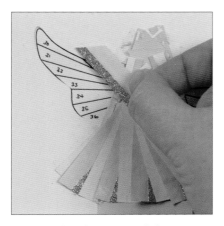

18. Apply glue around the outside of the wings. Attach a silver glitter paper strip to section 29.

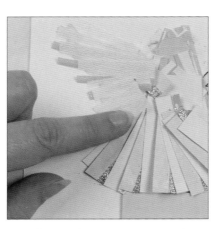

19. Cover the remaining sections on the left-hand wing using white iridescent paper.

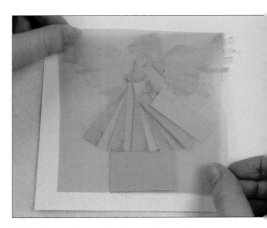

20. Complete the right-hand wing in the same way. Cut a piece of double-sided adhesive sheet to size, peel off one side and lay it sticky-side down over the back of the design.

21. Cut a piece of white card to fit over the back of the design. Remove the protective covering on the adhesive sheet and attach the card to it.

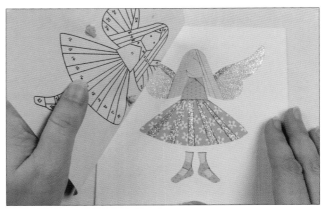

22. Turn the card over and remove the template, revealing the iris-folded design underneath.

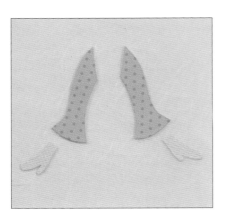

23. Cut out the arms from purple dotted paper and the hands from pale pink card, using the templates provided.

24. Glue the hands to the backs of the arms using all-purpose glue. Apply glue to the backs of the arms and attach them to the fairy.

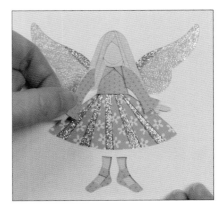
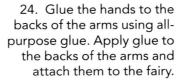

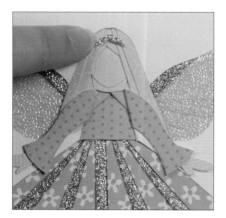

25. Cut out the tiara from silver glitter paper and attach it to the fairy's head using all-purpose glue.

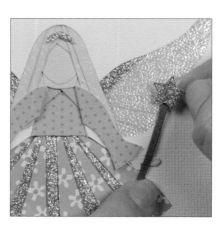

26. Make the wand by punching a star from silver glitter paper and attaching it to the end of a thin strip of purple card. Glue the wand to the fairy's hand.

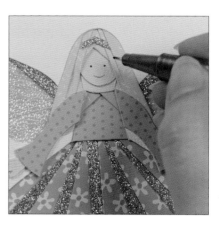

27. Dot in the eyes using a fine-nibbed pen, and draw in the mouth using a sharp pencil.

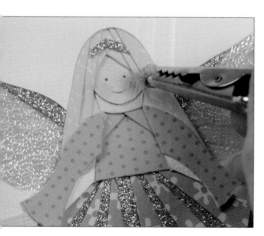

28. Add a touch of pink chalk to the cheeks using a pompom in a crocodile-clip applicator.

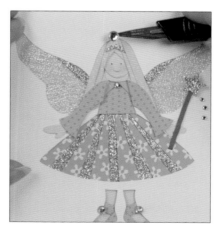

29. Attach silver, self-adhesive gemstones to the tiara, shoes and collar, and smaller versions falling like stardust from the wand.

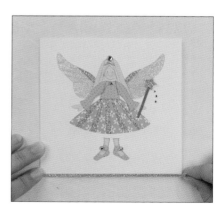

30. To complete the card, attach a strip of silver glitter paper across the base using double-sided sticky tape.

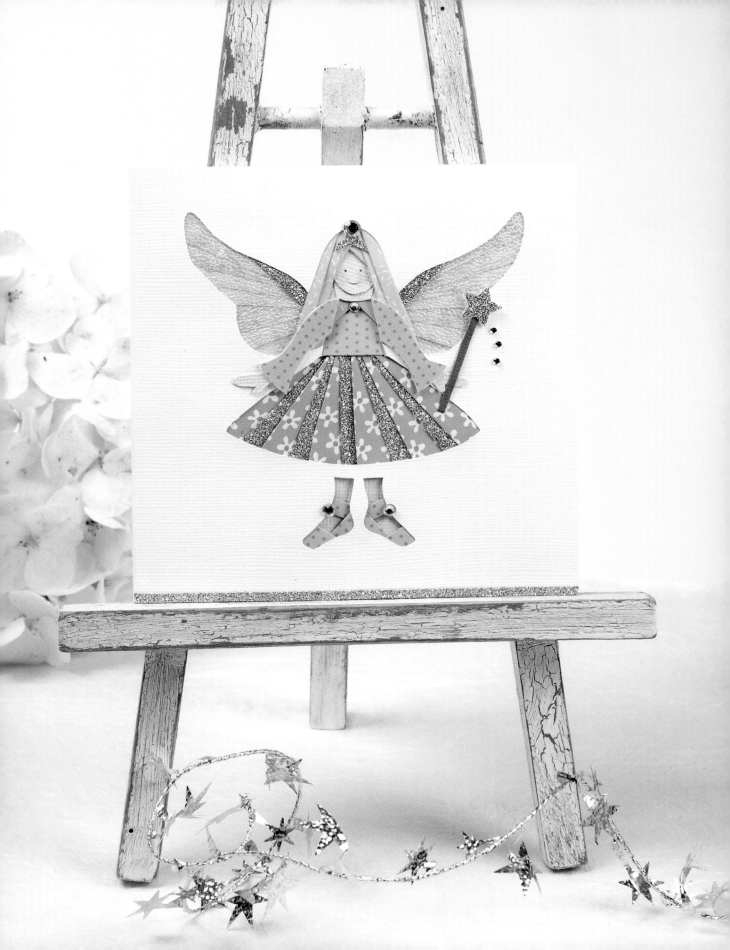

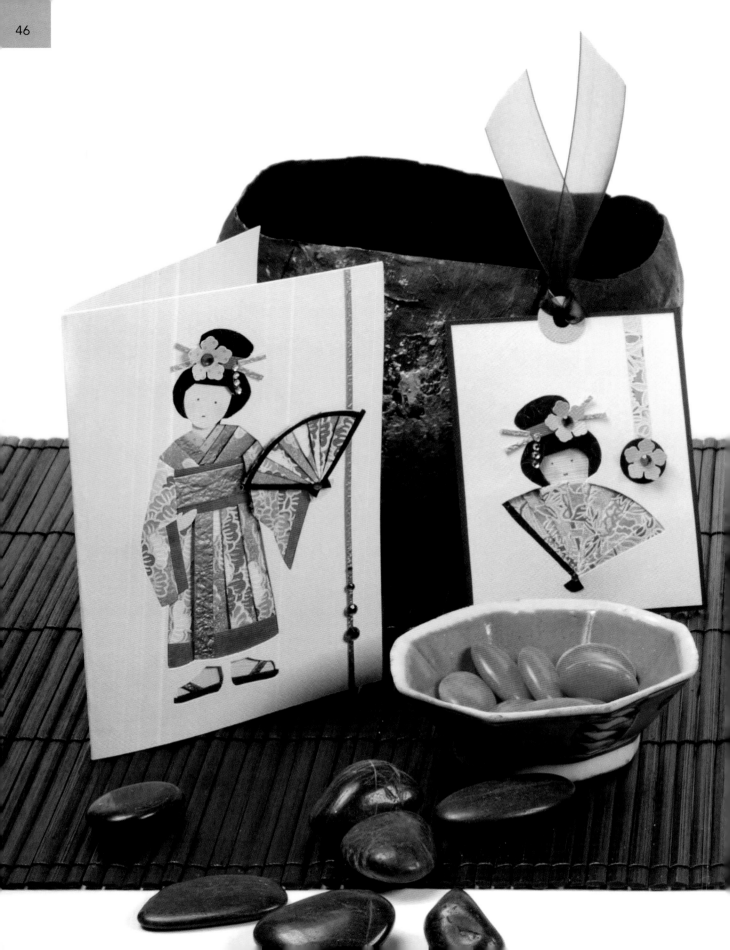

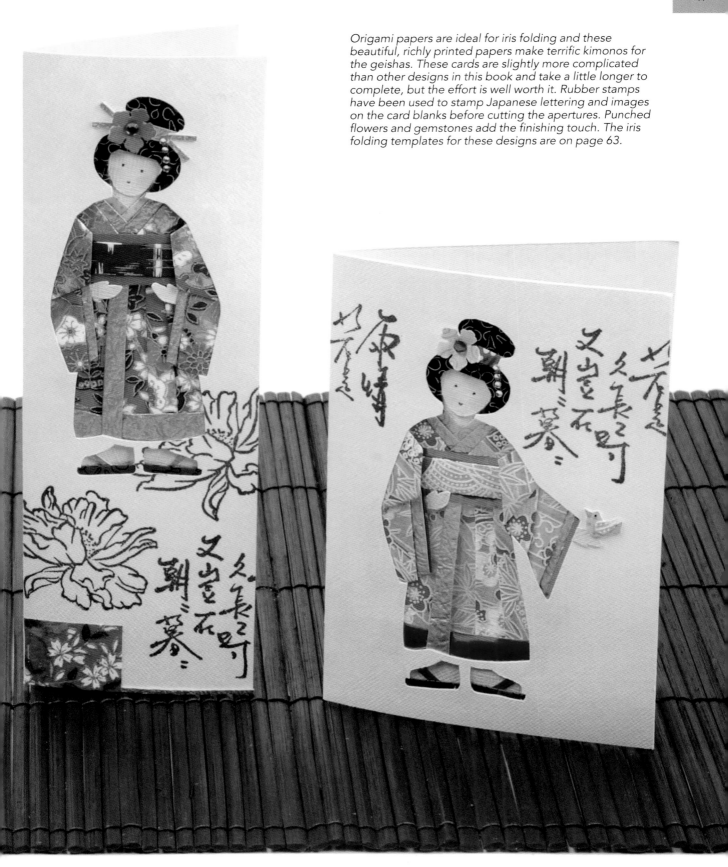

Origami papers are ideal for iris folding and these beautiful, richly printed papers make terrific kimonos for the geishas. These cards are slightly more complicated than other designs in this book and take a little longer to complete, but the effort is well worth it. Rubber stamps have been used to stamp Japanese lettering and images on the card blanks before cutting the apertures. Punched flowers and gemstones add the finishing touch. The iris folding templates for these designs are on page 63.

Christmas Star

This Christmas decoration really does have the 'wow factor' and looks wonderful hung from a wreath or swag. A completely different technique is used to fold the paper strips into points, resulting in an iris-folded design that resembles a patchwork. As in traditional iris folding, the design is worked from the back using folded layers of paper that are lined up on a template, but the finished look is very different. This design gives you the opportunity to use all those gorgeous glittery, iridescent and metallic papers for a large helping of Christmas sparkle.

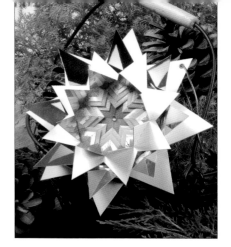

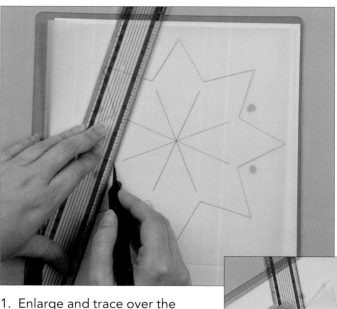

1. Enlarge and trace over the large star design (provided on page 61). Attach the tracing to the back of a piece of gold card using adhesive putty. Working on a cutting mat, cut out the design using a craft knife.

2. Cut along the lines in the centre of the design.

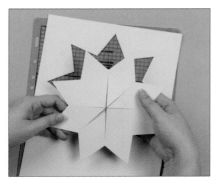

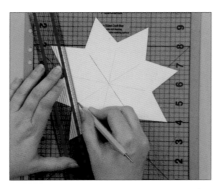

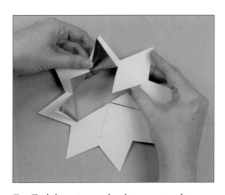

3. Remove the tracing and lift out the cut-out star.

4. Lay a ruler across the base of each central triangle and score along it using an embossing tool (these lines are marked as dotted lines on the template).

5. Fold outwards the central points along the score lines.

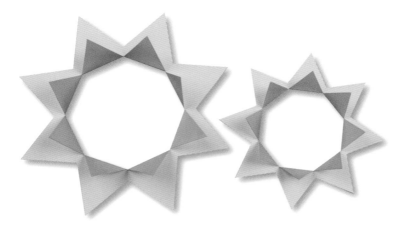

6. Repeat steps 1 to 5 using the smaller star pattern provided on page 61.

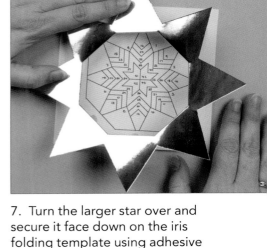

7. Turn the larger star over and secure it face down on the iris folding template using adhesive putty. Ensure the two are aligned accurately.

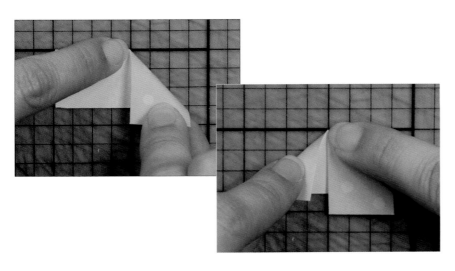

8. Cut 2cm (¾in) wide strips from five different green or gold papers. Cut these into 5cm (2in) lengths. Place one of these lengths on a cutting-mat grid so that the centre is aligned with one of the grid lines. Place your finger at the top in the middle and fold down first one corner and then the other to form a point.

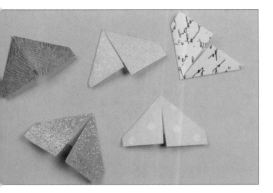

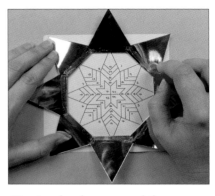

9. Repeat for all the remaining 5cm (2in) lengths. It doesn't matter if the two sides are slightly different lengths – it is far more important to make a neat, sharp point.

10. Apply glue around the outside of the aperture.

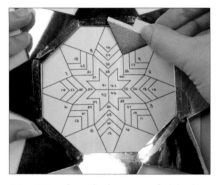

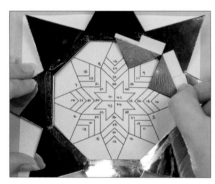

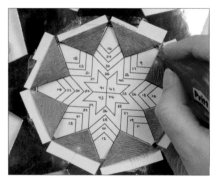

11. Attach a dark green folded point to section 1, ensuring the tip is aligned accurately with that on the template. Attach it with the folded join down.

12. Attach another dark green folded point to section 2 in the same way.

13. Continue round to section 8 to complete the outer ring. Apply glue to the bases of the folded points on which to secure the next ring of paper points (sections 9 to 16).

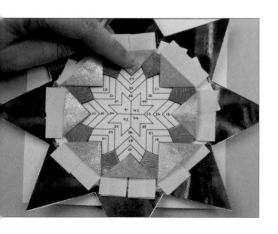

14. Complete sections 9 to 16 using green iridescent paper.

15. Apply glue to the bases of the folded points as before, and begin the next ring (section 17) using the white gold-printed folded paper.

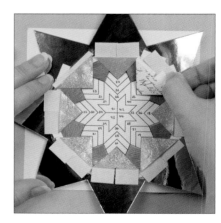

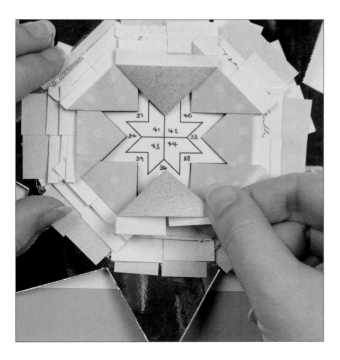

16. Following the same method, complete the ring (sections 17 to 24), and then the following ring (sections 25 to 32) using lime green dotted paper. For the next ring (sections 33 to 40) use gold glitter paper. Notice that this time you are placing opposite pairs of points rather than going round in a circle.

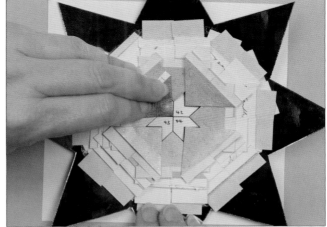

17. Complete the design by placing the four central points using the dark green patterned paper.

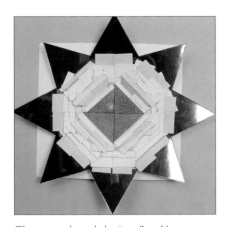

The completed design (back).

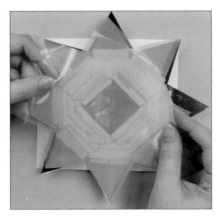

18. Cut out a piece of double-sided adhesive sheet using the pattern for the large star as a template, peel off one side and lay it sticky-side down over the back of the design.

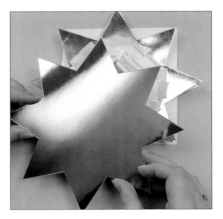

19. Cut out a second large gold star, minus the central cuts. Peel the protective layer off the adhesive sheet and lay the star face down over the top to neaten the back.

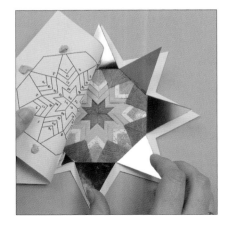

20. Turn the star over and remove the template, revealing the iris-folded design underneath.

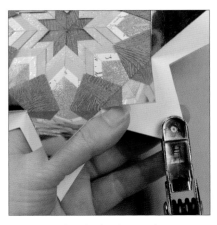

21. Punch a hole through one point of the star, close to the tip.

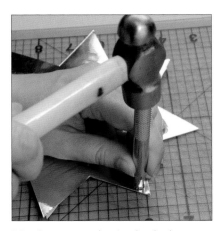

22. Set an eyelet in the hole to strengthen it.

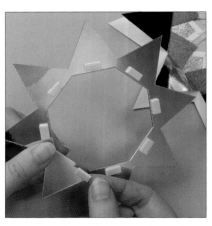

23. Attach 3D foam pads to the back of the smaller gold star – one at the base of each point.

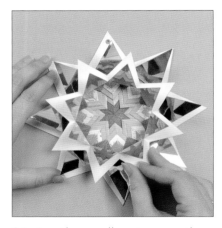

24. Lay the smaller star over the larger one. Centre it over the iris-folded design, and position it so that the points lie in-between those of the larger star.

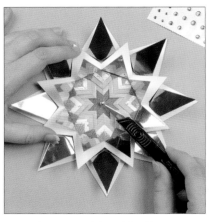

25. Place a gold, self-adhesive gemstone in the centre of the star.

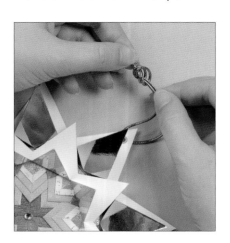

26. Thread a length of green cord through the hole and tie it in a knot.

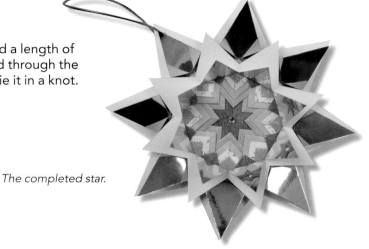

The completed star.

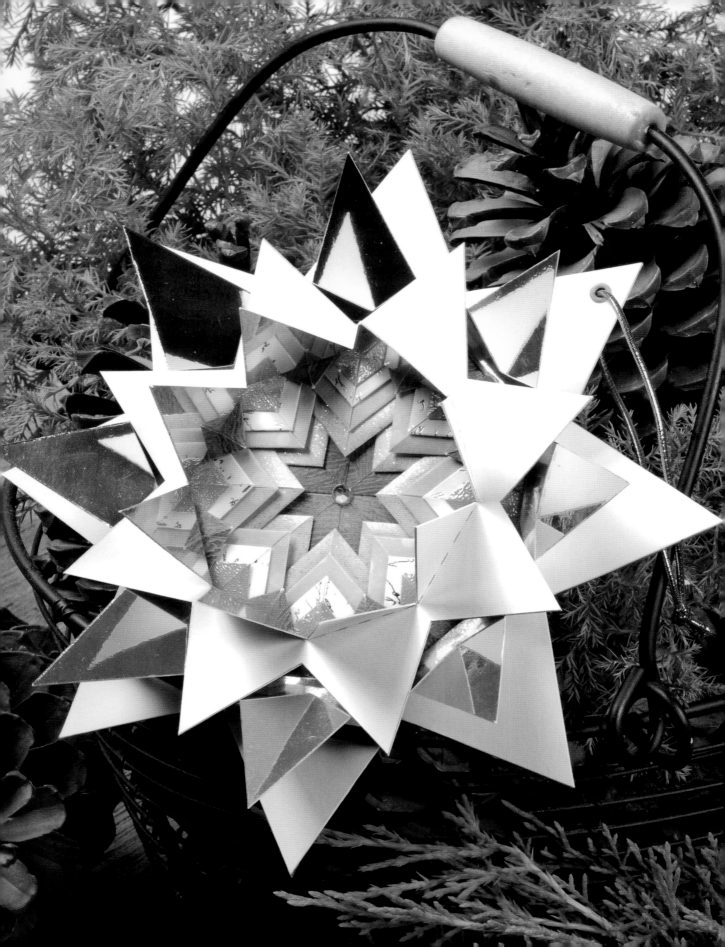

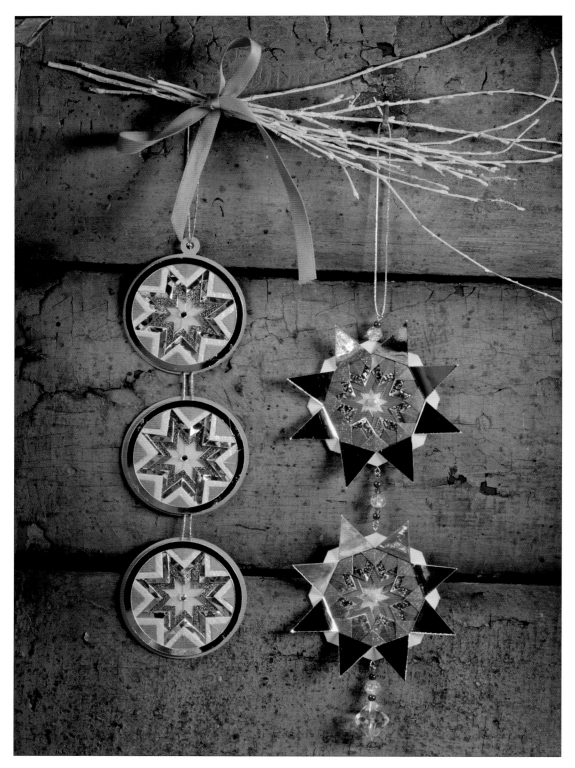

Use shades of pink and silver with a single layered star aperture or a plain ring aperture to create these smaller hanging tree stars. The design can also be used as the centrepiece for a special Christmas card or tag.

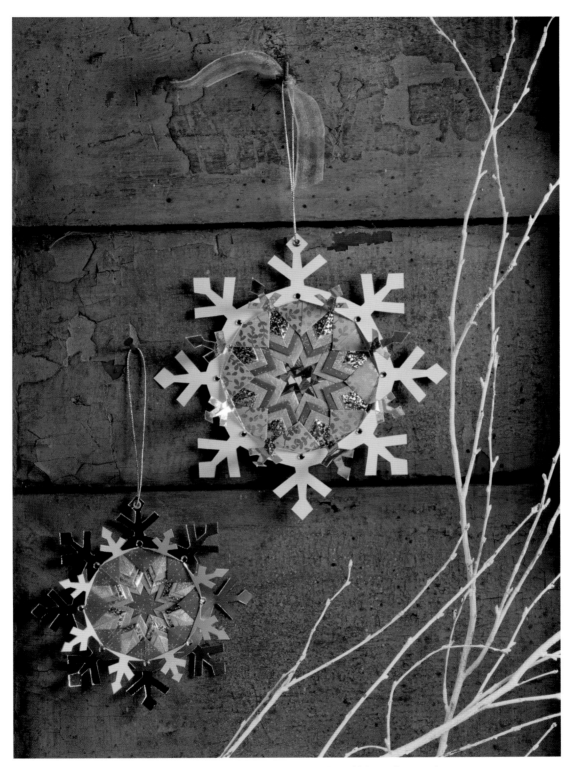

Cut your aperture into a snowflake shape and use cool shades of blue, silver and mauve to make these icy decorations. The templates for all the variations are on pages 60–62.

Templates

The templates provided on the following pages are all shown full size, except where indicated otherwise. Transfer them to your card following the directions on page 13.

Pretty Pink Parcel, page 16

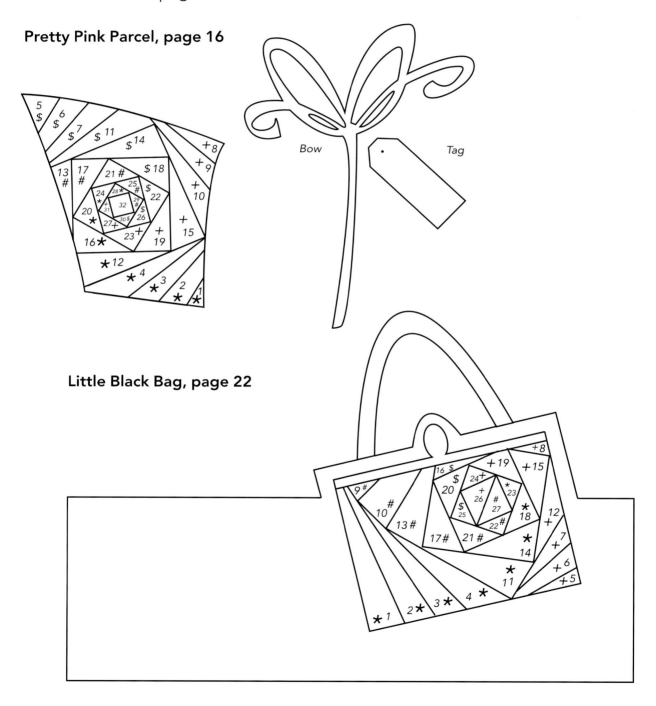

Bow *Tag*

Little Black Bag, page 22

Baby designs, page 27

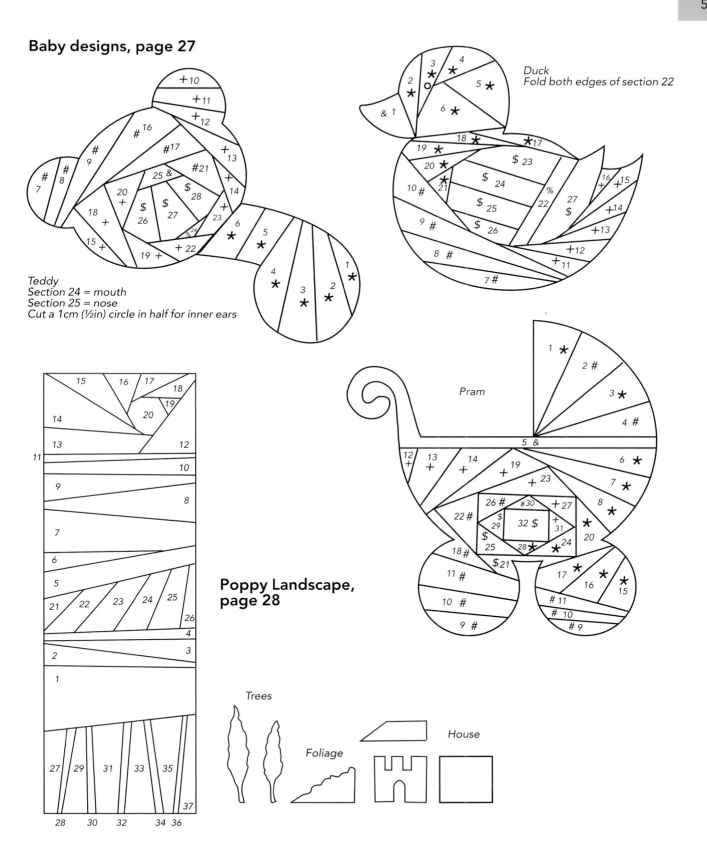

Duck
Fold both edges of section 22

Teddy
Section 24 = mouth
Section 25 = nose
Cut a 1cm (½in) circle in half for inner ears

**Poppy Landscape,
page 28**

Pram

Trees

Foliage

House

Tropical Cruise, page 33

Bluebell Wood, page 33

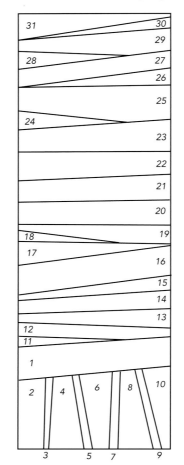

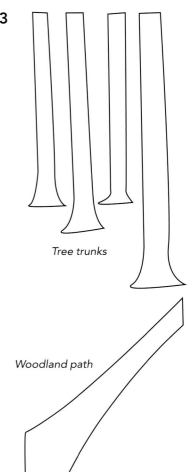

Tree trunks

Woodland path

Cruise ship

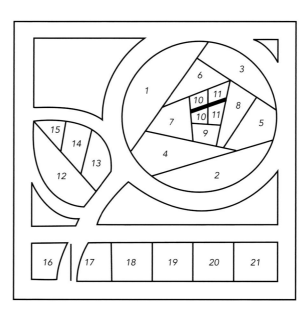

Art Nouveau Trinket Box, page 34, and greetings card, page 38

Japanese Scene, page 33

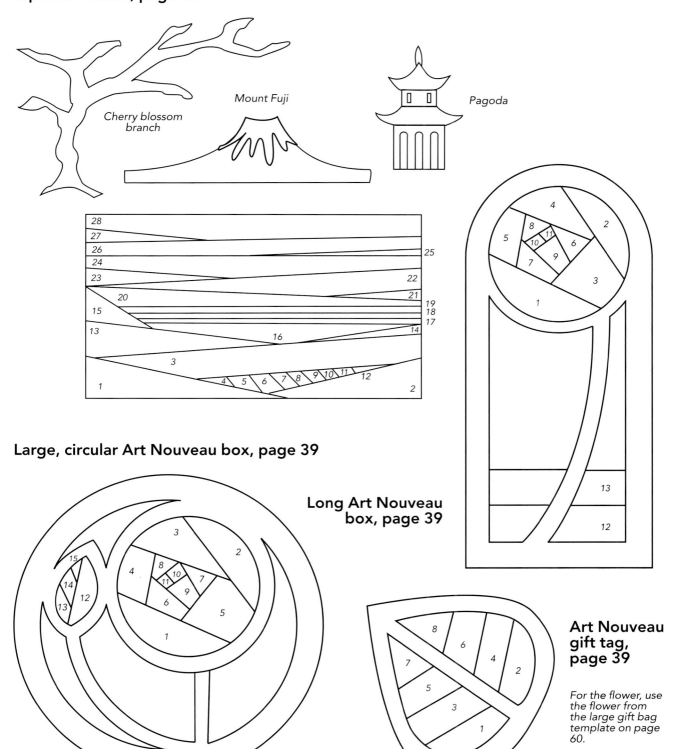

Cherry blossom branch

Mount Fuji

Pagoda

Large, circular Art Nouveau box, page 39

Long Art Nouveau box, page 39

Art Nouveau gift tag, page 39

For the flower, use the flower from the large gift bag template on page 60.

Small, circular Art Nouveau gift box decoration, page 38

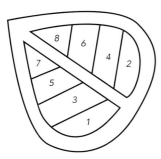

For the flower, use the flower from the large gift bag template.

Tag on small gift bag, page 39

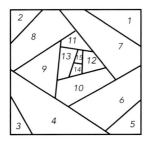

Snowflake tree decoration, page 55

Small snowflake

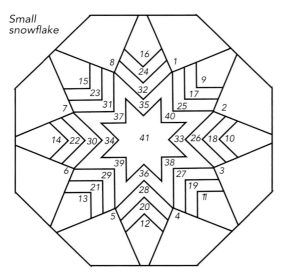

For the large snowflake, use the Christmas Star template opposite.

Large Art Nouveau gift bag, page 39

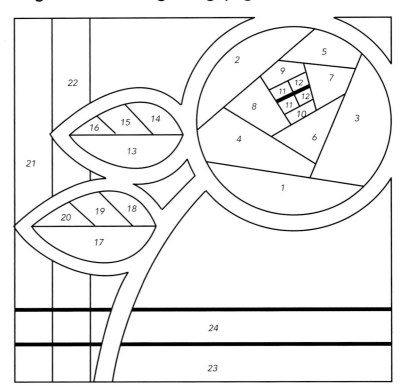

Christmas Star, page 48

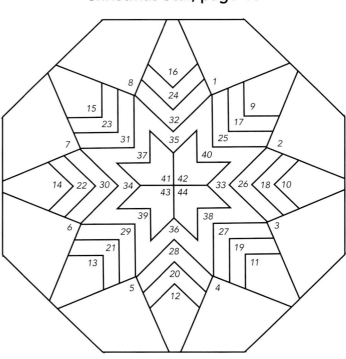

Christmas Star (cont'd), page 48

*Large star (half actual size)
For the small star, use the
aperture template for the
purple hanging tree stars
below.*

Pink, circular hanging tree decoration, page 54

Greetings card, page 3

Purple hanging tree stars, page 54

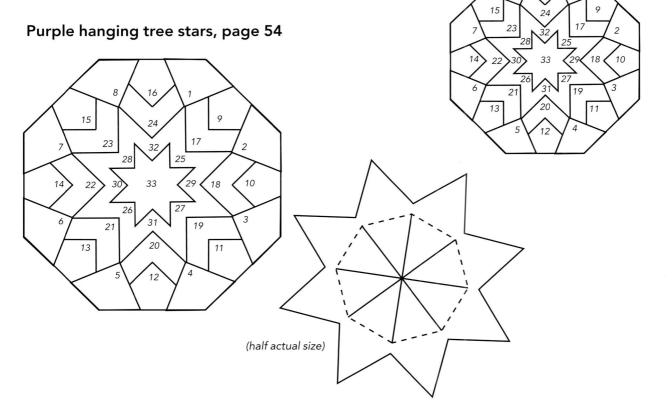

(half actual size)

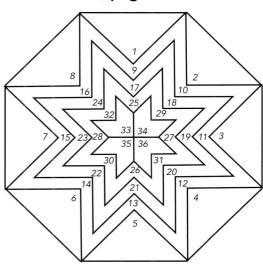

Snowflake hanging decoration, page 55

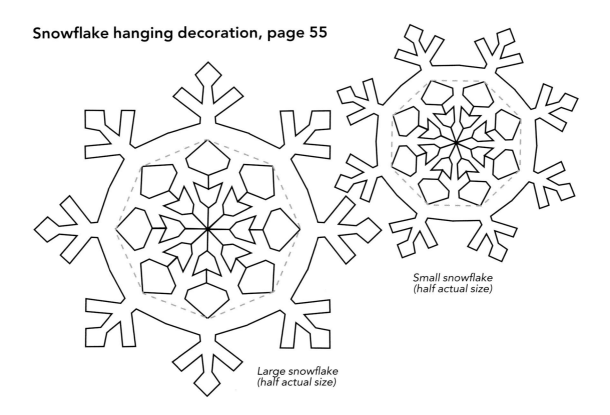

Small snowflake
(half actual size)

Large snowflake
(half actual size)

Sparkly Fairy Card, page 40

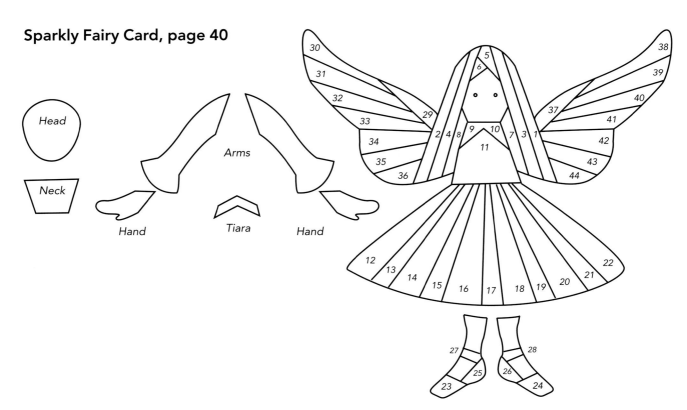

Head

Neck

Arms

Hand

Tiara

Hand

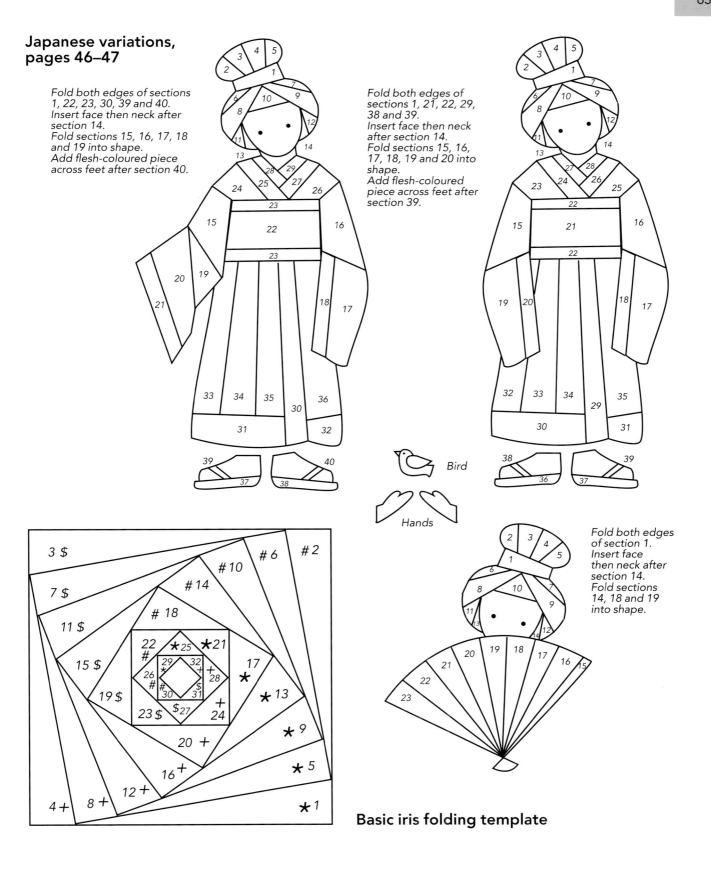

Japanese variations, pages 46–47

Fold both edges of sections 1, 22, 23, 30, 39 and 40.
Insert face then neck after section 14.
Fold sections 15, 16, 17, 18 and 19 into shape.
Add flesh-coloured piece across feet after section 40.

Fold both edges of sections 1, 21, 22, 29, 38 and 39.
Insert face then neck after section 14.
Fold sections 15, 16, 17, 18, 19 and 20 into shape.
Add flesh-coloured piece across feet after section 39.

Fold both edges of section 1.
Insert face then neck after section 14.
Fold sections 14, 18 and 19 into shape.

Bird

Hands

Basic iris folding template

Index

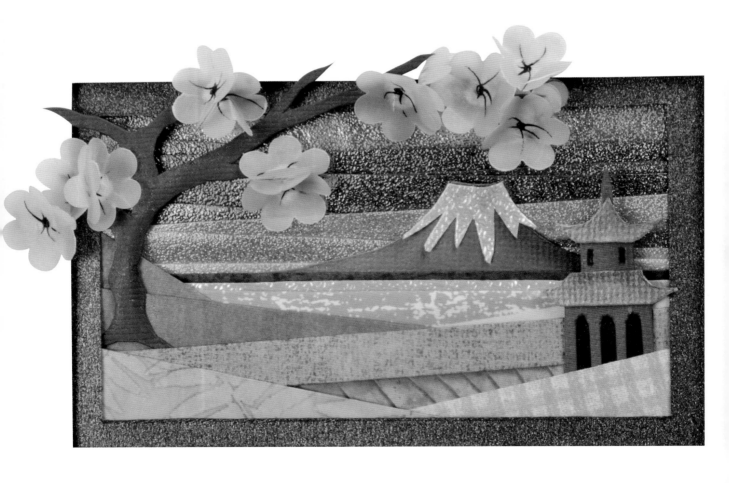